REALISTIC
FIGURE
DRAWING

REALISTIC
FIGURE
DRAWING

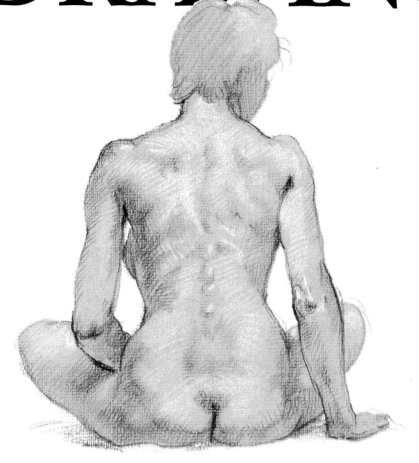

Joseph Sheppard

NORTH
LIGHT
BOOKS

Cincinnati, Ohio

About the Author

Joseph Sheppard attended the Maryland Institute of Art, where he studied with Jacques Maroger, the former technical director of the Louvre and reformulater of the painting medium used by the Old Masters. He has received numerous awards, including a Guggenheim Traveling Fellowship. His work is in many prestigious collections throughout the United States and he has received several major commissions for murals in Baltimore and Chicago. He is the author of six art instruction books and until 1976, he taught drawing, painting, and anatomy at the Maryland Institute of Art. He is a member of the Allied Artist's of America, the Knickerbocker Artists, New York; and the National Sculpture Society. Mr. Sheppard resides in Pietrasanta, Italy, where he maintains a studio.

Realistic Figure Drawing.

Copyright © 1991 by Joseph Sheppard.

Manufactured in China. All rights reserved. No part of this book may be reproduced in any form or by any electronic or mechanical means including information storage and retrieval systems without permission in writing from the publisher, except by a reviewer, who may quote brief passages in a review. Published by North Light Books, an imprint of F&W Publications, Inc., 4700 East Galbraith Road, Cincinnati, Ohio, 45236. (800) 289-0963. First edition.

Other fine North Light Books are available from your local bookstore, art supply store or direct from the publisher.

08 07 06 05 04 17 16 15 14 13

Library of Congress Cataloging-in-Publication Data

Sheppard, Joseph
 Realistic figure drawing / by Joseph Sheppard.—1st ed.
 p. cm.
 Includes index.
 ISBN 0-89134-374-1
 1. Figure drawing—Technique. I. Title
NC765.S45 1991
743′.4—dc20
 90-21787
 CIP

Edited by Greg Albert
Designed by Cathleen Norz

To Rita

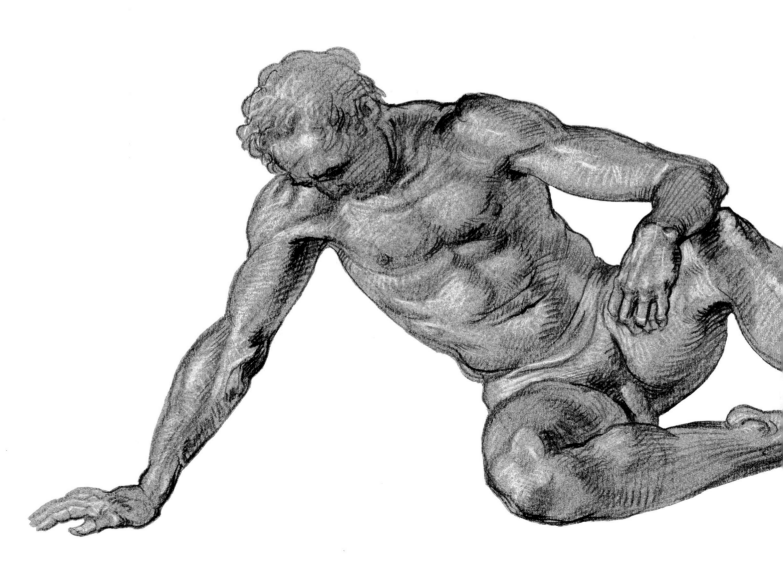

CONTENTS

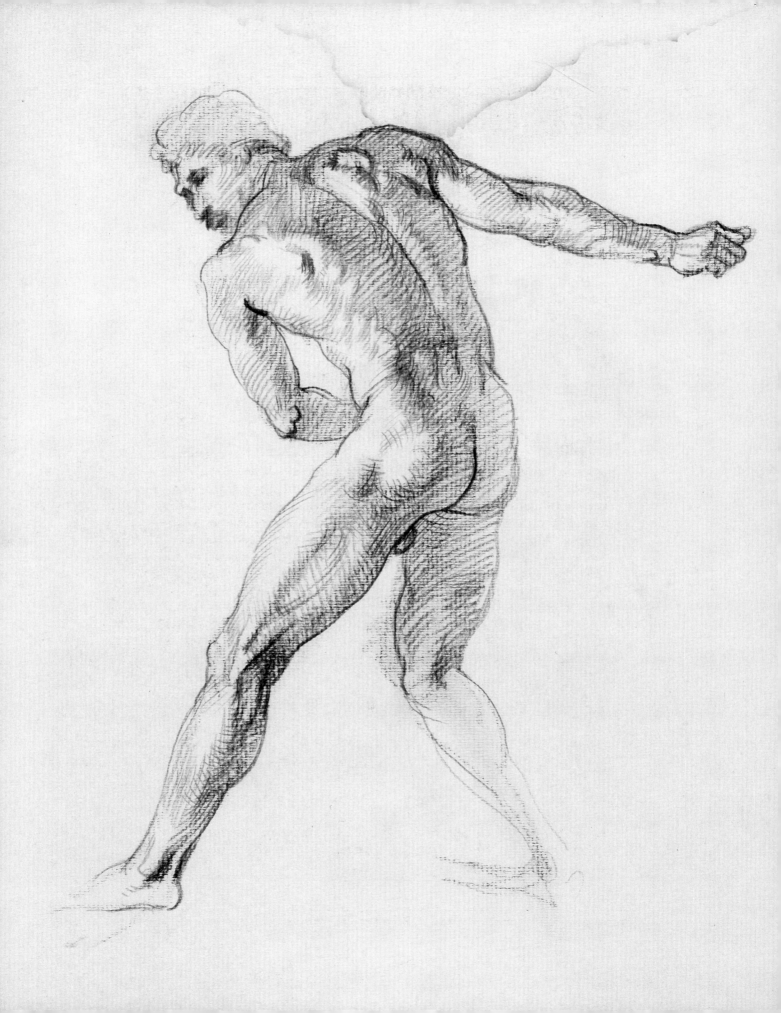

INTRODUCTION

Although I paint and sculpt just about every subject, my real joy is in, and my best work is of, the human figure. So it was very natural, when I started to teach, that I should teach a course in life drawing.

Many of the drawings in this book I did in the life class, working along with the students. They are drawings of either two-minute or twenty-minute poses. I selected them from about ten years' work.

When you draw the human figure you draw something alive, not a still life. I recommend drawing from the *live* model. First use quick poses of one to three minutes, and then longer poses up to twenty minutes. If you try to draw the entire figure (including hands and feet) in the sketches, you will eventually find that twenty-minute poses will give you ample time. Very few of the drawings in this book took more than twenty minutes. Over-rendering can freeze the figure and make it look like a statue—dead.

It is extremely important to place a single source of light on the model. The Old Masters discovered that one light source, preferably high and slightly to the front and side, gives the best light for creating depth and form.

An understanding of anatomy and proportion is a *must*. You will soon discover that you draw and see only what you already *know*. In my teaching I find that when a student first starts drawing from the model, he sees only outline. After the shadows are pointed out to him, he tries to render form. Once a muscle, tendon or bone is explained, he will always recognize it and include it in his drawing. The more he learns about the figure, the more he sees.

The drawings in this book are arranged first by position—standing, sitting, kneeling, and then by viewpoints—front, back and side. I discuss each drawing in much the same way that I would if I were teaching my class. Each drawing dictates what should be said about it. In one section, for example, I might talk about the wrist because it's prominent in a particular drawing, and then not mention the wrist again until another chapter, where it again becomes important.

In the course of discussing the many positions and viewpoints shown in this book, most of the important aspects of drawing the figure are covered: anatomical points, proportion, attitudes and weight distribution, rendering, variations and types, foreshortening, the figure in motion, and whatever else might arise.

I've deliberately used different mediums to let you see as much variety as possible. There are unlimited techniques and mediums with which you can draw. Feel free to use whatever tools and techniques you desire. It's not what you draw with, but how you draw, that is most important.

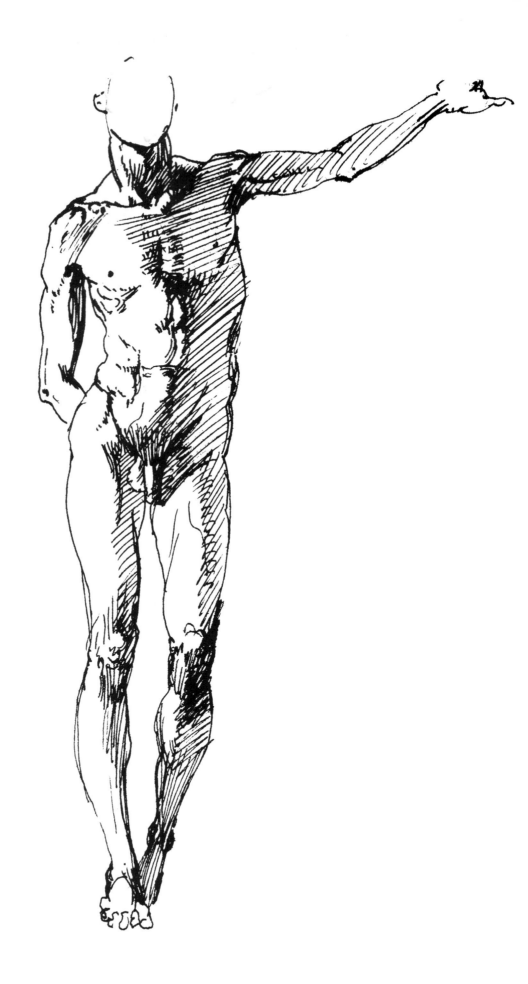

PROPORTIONS

I

P roportions vary from person to person. However, classic Greek and Renaissance figures were eight heads in height, the head being used as the unit of measure. The Mannerist artists created elongated figures of nine or more head lengths. In nature, the average height of the human form is seven and a half heads. The figure that measures eight heads long seems by far the best: It gives dignity to the figure and also seems to be the most convenient for measuring.

The classical male figure measured two heads across the shoulders and one and a half across the hips. The female width measurements are just the opposite of the male's.

Certain bones project on the surface of the body and become helpful "landmarks" in measuring proportion. These bones are always next to the skin. On a thin body they protrude, on a heavier one they show as dimples.

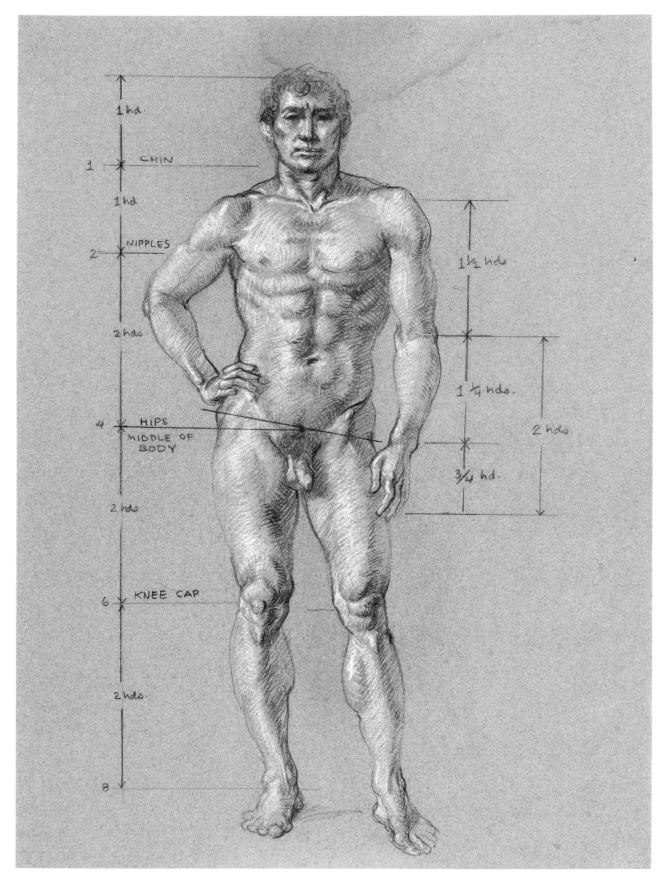

1 hd.

1 — CHIN

1 hd

2 — NIPPLES

2 hds

1½ hds

1¼ hds.

2 hds

4 — HIPS
MIDDLE OF BODY

¾ hd.

2 hds

6 — KNEE CAP

2 hds.

8

Standing, front view.

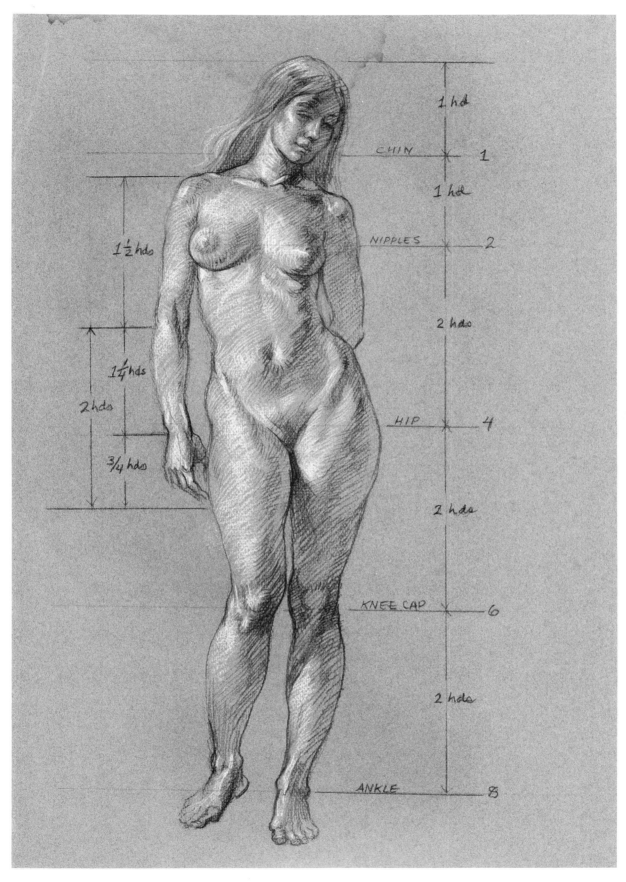

1 hd

CHIN 1

1 hd

NIPPLES 2

1½ hds

2 hds

1¼ hds

2 hds

HIP 4

¾ hds

2 hds

KNEE CAP 6

2 hds

ANKLE 8

Standing, front view.

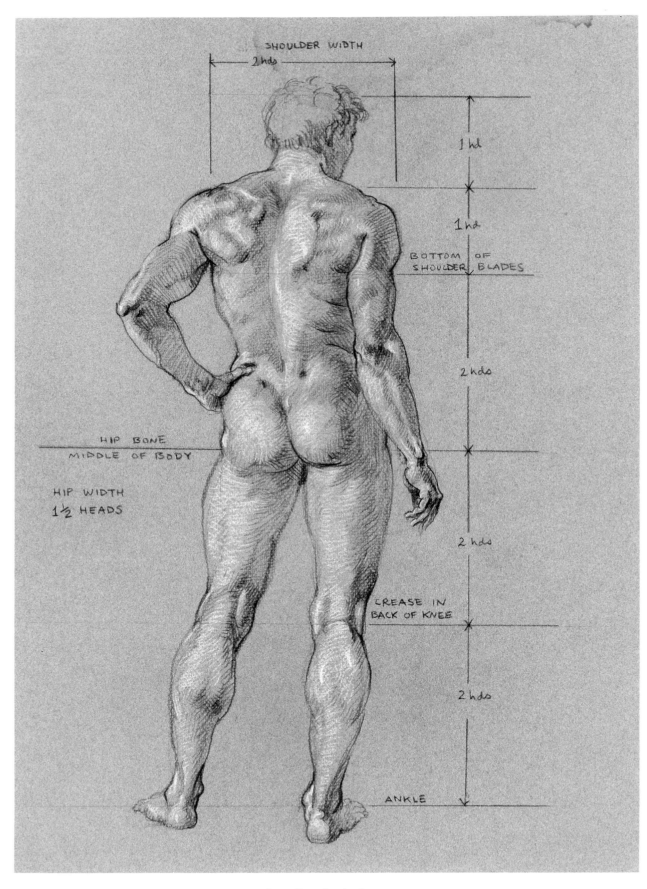

SHOULDER WIDTH
2 hds

1 hd

1 hd

BOTTOM OF
SHOULDER BLADES

2 hds

HIP BONE
MIDDLE OF BODY

HIP WIDTH
1½ HEADS

2 hds

CREASE IN
BACK OF KNEE

2 hds

ANKLE

Standing, back view.

6

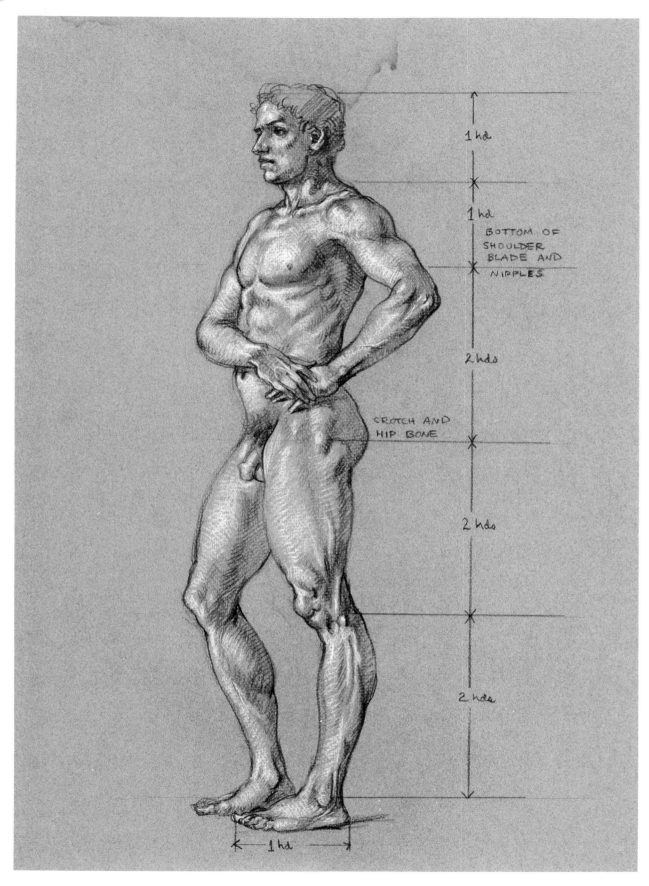

1 hd

1 hd
BOTTOM OF
SHOULDER
BLADE AND
NIPPLES

2 hds

CROTCH AND
HIP BONE

2 hds

2 hds

1 hd

Standing, side view.

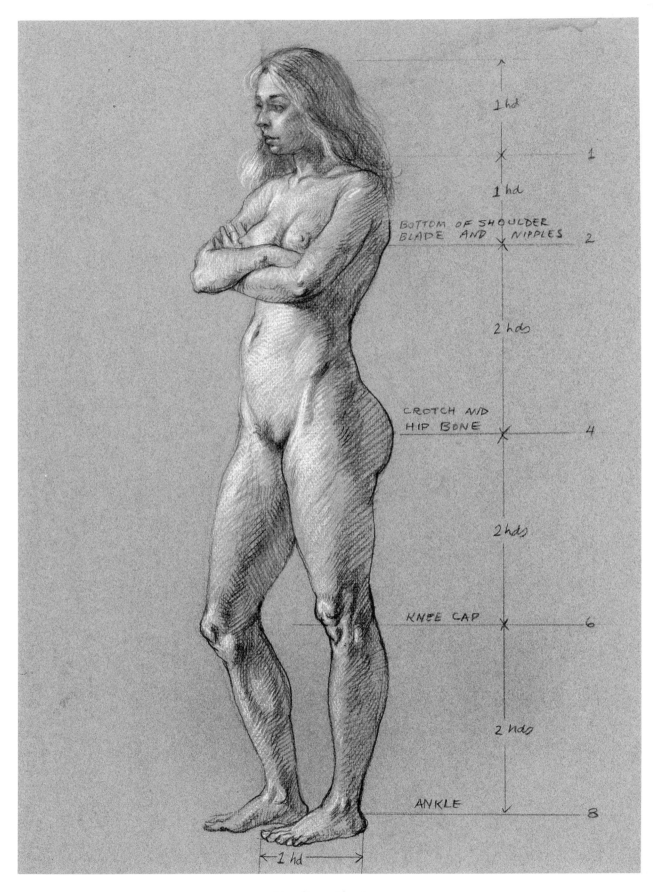

Standing, side view.

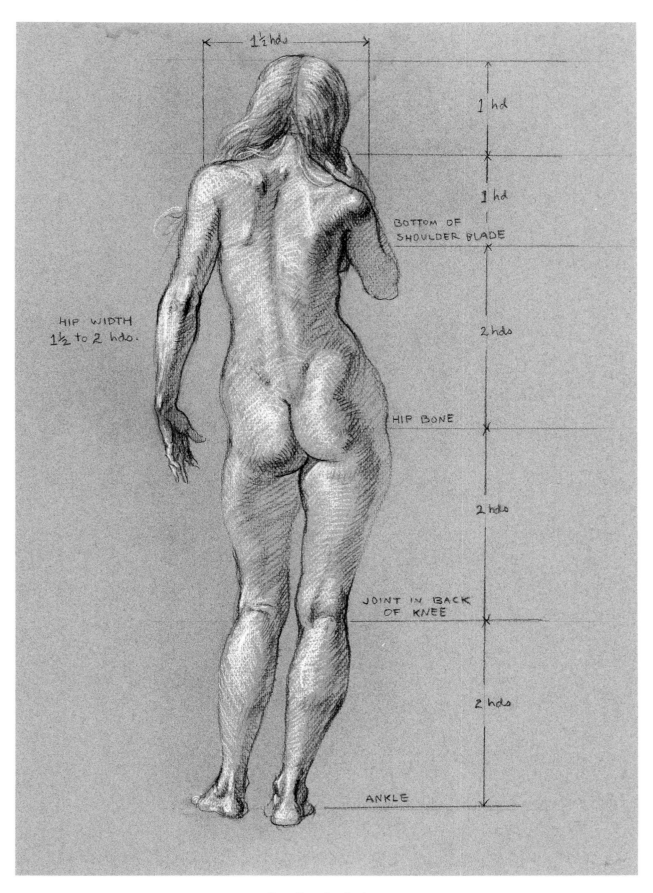

1½ hds

1 hd

1 hd

BOTTOM OF
SHOULDER BLADE

HIP WIDTH
1½ to 2 hds.

2 hds

HIP BONE

2 hds

JOINT IN BACK
OF KNEE

2 hds

ANKLE

Standing, back view.

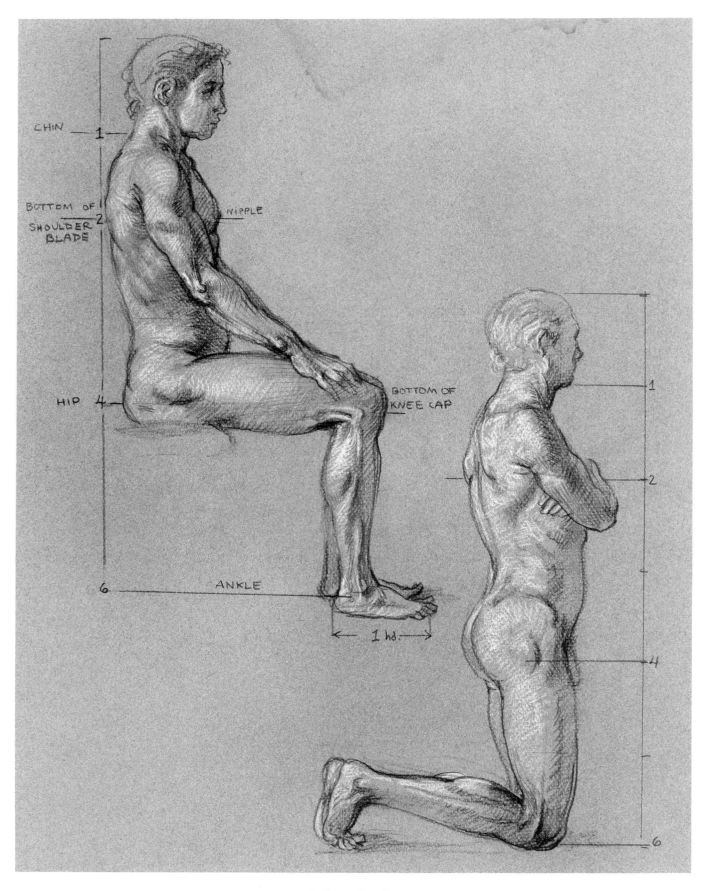

CHIN — 1

BOTTOM OF SHOULDER BLADE — 2

NIPPLE

HIP — 4

BOTTOM OF KNEE CAP

6 — ANKLE

1 hd.

1

2

4

6

Sitting. Kneeling.

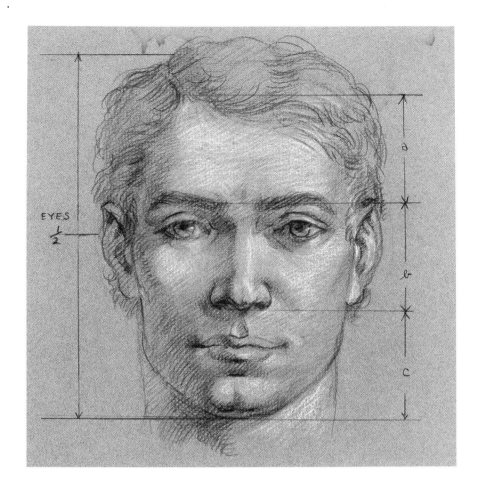

Head, full face. The eyes are halfway between the top of the head and the bottom of the chin. The face can be divided into three equal parts: (a) from the hairline to the eyebrows, (b) from the eyebrows to the bottom of the nose, and (c) from the nose to the bottom of the chin. The ears are in line with the eyebrows and the bottom of the nose. Between the eyes, there is a space equal to the width of one eye.

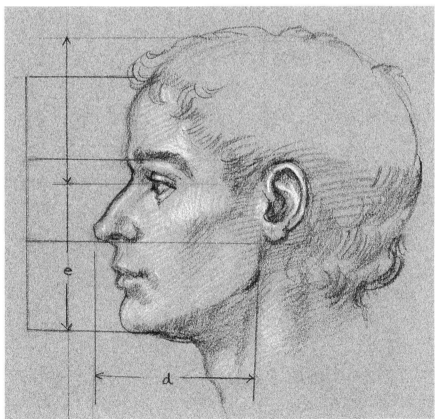

Head, profile. The distance from the tip of the nose to the end of the jaw (d) is equal to half the head height (e).

Rendering Form
in
Light and Shade
II

Human body forms are either cylindrical or spherical. Angular planes in the body always end in soft, rounded edges. Whether rendering the torso or a finger, you'll find both forms present the same problems and have the same solutions. Those solutions require a firm understanding of light and shade.

If a sphere is lit from above and to one side, several areas of light and shade are created. The general area of tone in the light is considered the middle tone. The brightest section of this area of middle tone is the highlight; it is nearest to the light source. The area turned away from the light is the shadow. The shadow area is darkest next to the middle tone, at a point called the accent of the shadow. Toward the outside of the shadow area, reflected light bounces off other objects or off the background and back to the sphere. Areas touched by such reflected light are never as bright as areas in direct light.

When the sphere touches or is near another object, it throws a cast shadow upon it. The cast shadow is darkest next to the object that is casting it; it starts out dark and then lightens and diffuses as it pulls away. To summarize, proceeding in order of values (not position) from the very lightest tones to the very darkest ones on the sphere, there is the highlight, the middle tone, reflected light, shadow and cast shadow, the accent of the shadow, and finally, the beginning of the cast shadow.

The Old Masters discovered that a single light source was the perfect light. Most of these painters used a light on their subjects that would give them three-quarters light and one-quarter shadow.

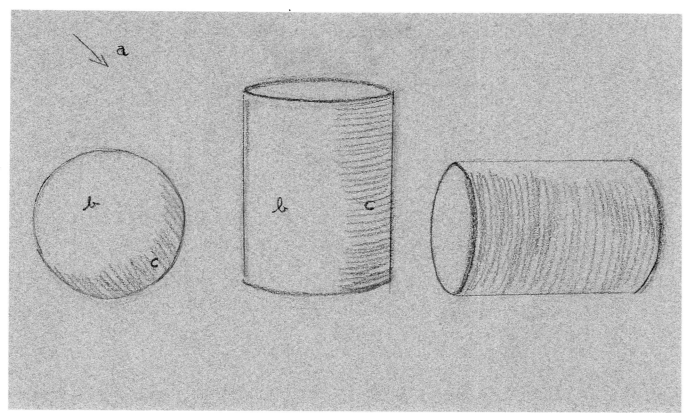

A single light source (a), high and to the side, creates an effect that is two-thirds light (b), and one-third shadow (c) on the cylinder. A somewhat different distribution of light and shadow appears on the cylinder when it's lying on its side (right).

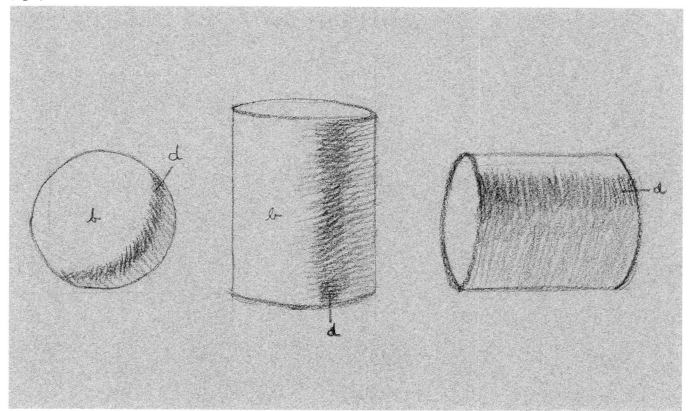

The shadow accent (d) is the darkest part of the shadow and is always next to the middle tone in the light (b).

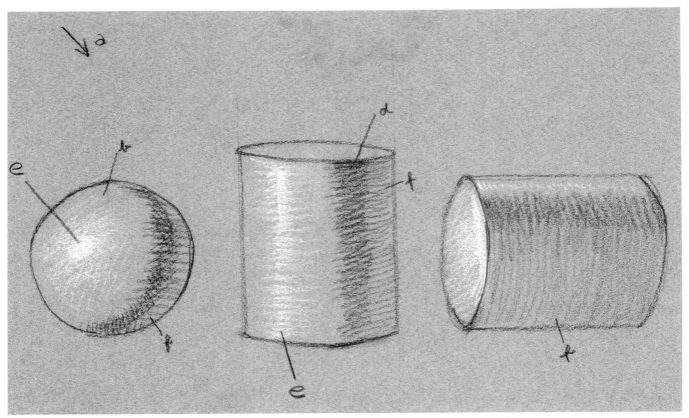

The highlight (e) is in the center of the middle tone in the light (b). The lighter part of the shadow is the reflected light (f).

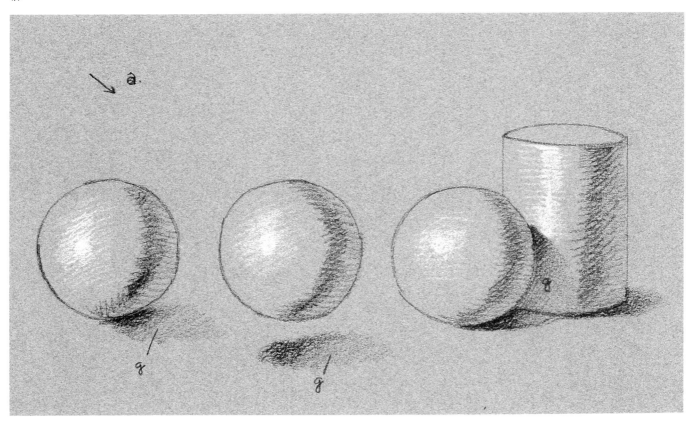

The cast shadow (g) is always darker next to the object casting the shadow. The cast shadow determines where the object sits in space and how it is related to other objects.

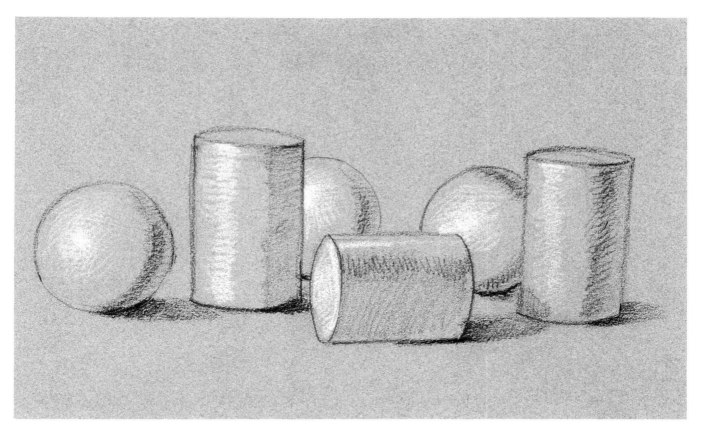

A group of objects. The cast shadows explain where objects are in relation to each other.

FORMS OF THE FIGURE

III

In discussing the forms of the figure, we have to see what differences there are between male and female. Females usually carry more fat tissue than males, which covers the skeletal and muscular forms and gives a soft, rounded look. The female is narrow in the shoulders and wide at the hips, just the opposite of the male. The bones of both skeletons are the same, but, with the exception of the hips, the female is smaller. The female facial features are finer and more delicate than the male's. The neck is more slender and appears longer and doesn't have a distinct Adam's apple. The collarbone is more horizontal, and muscle bulk is not evident in the chest and shoulders. The breasts sit on top of chest muscles and vary in size and shape. The female waist is higher than the male's and the thighs and buttocks are heavier and smoother. The navel is below the waist and is deepset. The angle of the legs from the hips to the knee is greater in the female and gives her the tendency to appear knock-kneed, while the male tends to appear bowlegged. She has smaller hands and feet, and her body has less hair.

The male jaw is prominent and his nose angular and generous. His neck is thick and his shoulder muscles large, pulling the collar bones upward as they point out towards the shoulder tips. All of this gives his neck a shorter look than the female's. His feet and hands are larger in proportion to his body. He may have a noticeable beard, as well as a thin coat of body hair that becomes dense on his chest, pubic area, and under his arms.

The male skeleton is larger, and the muscles more developed than the female's. Also, the male figure carries less body fat, which gives him a more angular look. His shoulders are wide and his hips narrow.

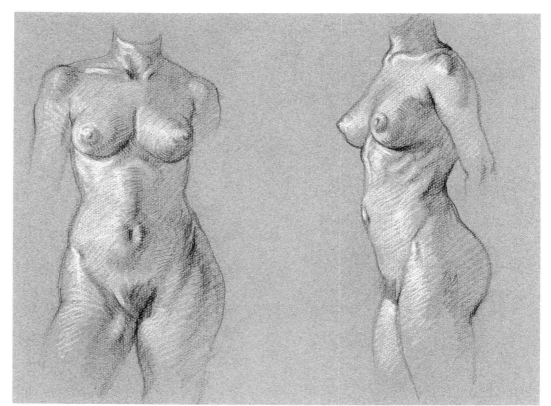

Left: *The navel is deepset in the belly. The waist is high and the belly sits into the pelvic basin. The two front points on the pelvis project forward.*

Right: *The ribs show under the breasts and have a downward slant from back to front.*

triangle

butterfly wings

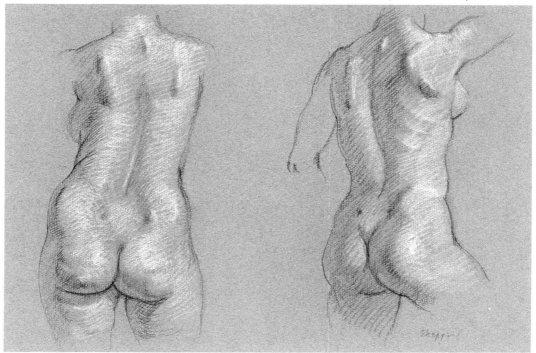

Left: *The muscles and fat of the buttocks create a butterfly shape (see diagram at left). At the base of the spine, between the two cheeks, there is a triangular shape formed by two dimples and the crease between the buttocks.*

Right: *The shoulder bones show on the surface and move with the arm. At the base of the neck the vertebrae are visible.*

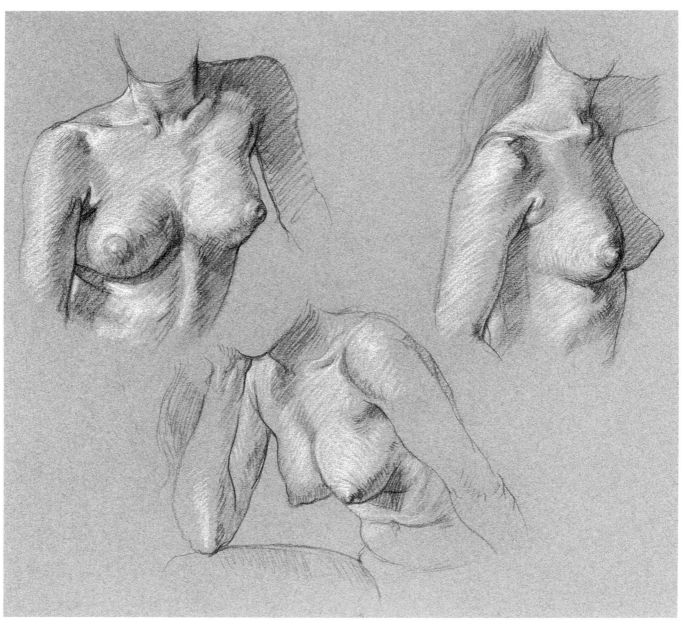

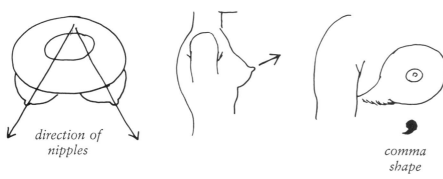

cross section

direction of
nipples

comma
shape

Top left: *The breasts are wider than they are high. The nipples point outward from the middle and slightly upward (see diagrams at left). The neck is a cylindrical shape that fits into the torso behind the collarbones.*

Center: *The breasts attach loosely to the underlying chest muscles. The chest muscles extend into the arm, forming the front wall of the armpit.*

Top right: *Fat extending behind the breast toward the armpit creates a comma shape (see diagram at left). The top outline of the breast is a long, slow curve to the nipple. The bottom outline is a short, sharp curve.*

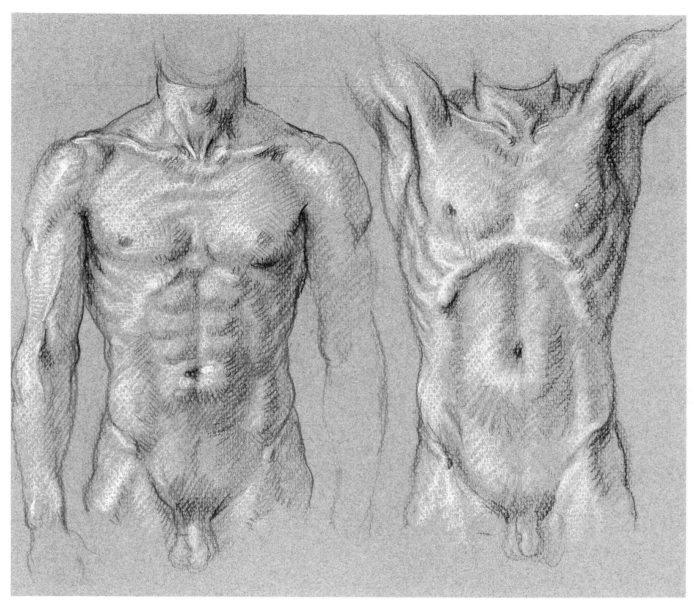

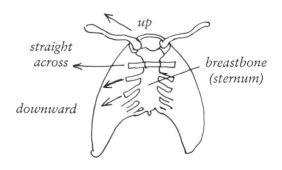

up

straight
across

downward

breastbone
(sternum)

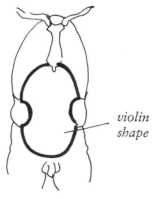

violin
shape

Left: *The collarbones angle upward away from the base of the neck. The ribs attach to the breastbone or sternum. The rib cage and pelvic basin form a violin shape (see diagrams at left).*

Right: *The chest muscles flatten and stretch up into the arms. The ribs start high in the back and extend downward toward the front. The rib cage becomes prominent when the arms are raised.*

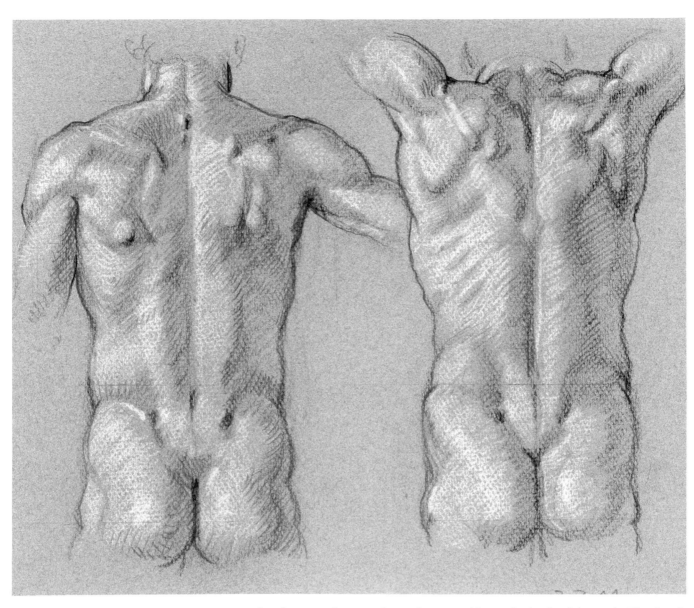

Left: *The seventh cervical vertebra is visible on the back of the neck. The shoulder blades are prominent, and two dimples are formed by the pelvic crests. A flat triangle is formed by the two dimples and the crease in the buttocks.*

Right: *When the arms are raised, the angle of the shoulder blades follows the arms.*

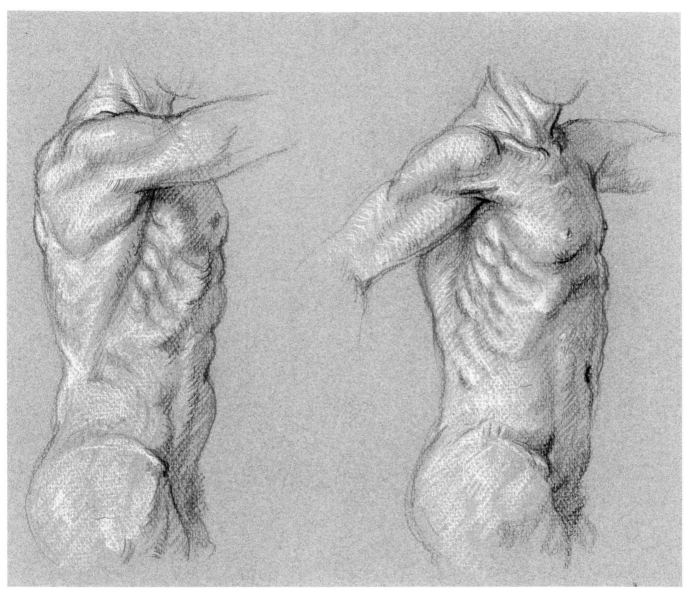

finger-
like
muscles

ribs

Left: *Small finger-like muscles attach to the ribs on the side of the rib cage, making a break in the line of their downward slant (see diagram at left). When the arm is raised forward, it's obvious the muscles of the back extend into the arm.*

Right: *When the arm is pulled back, the chest muscle forming the front wall of the armpit extends out into the arm.*

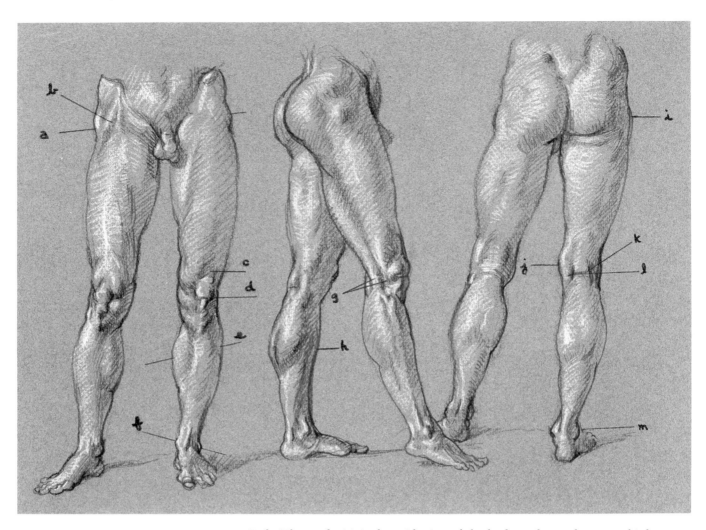

Left: *The angle (a) is the midpoint of the body and goes from one hipbone through the pubic area to the other hipbone. Muscles attached to the pelvis create an upside-down V shape (b). The locked knee creates a depression above the kneecap (c). The kneecap is rounded and its bottom is the sixth head measurement (d). The outside of the calf is higher than the inside (e). The angle (f) of the ankle runs the opposite way, with the inside of the ankle high and the outside low.*

Center: *Two strap-like tendons from the upper leg attach to the top of the lower leg on the outside of the knee (g). The front of the shin has a slight S shape (h).*

Right: *The hipbone protrudes on the male figures (i). The inside of the knee has a sharp angle to it (j). The tendons on the back of the knee and the folding crease form the letter H (k). The midpoint of the leg (l) is the sixth head measurement. The ankle is the eighth head measurement and the inside is higher than the outside (m).*

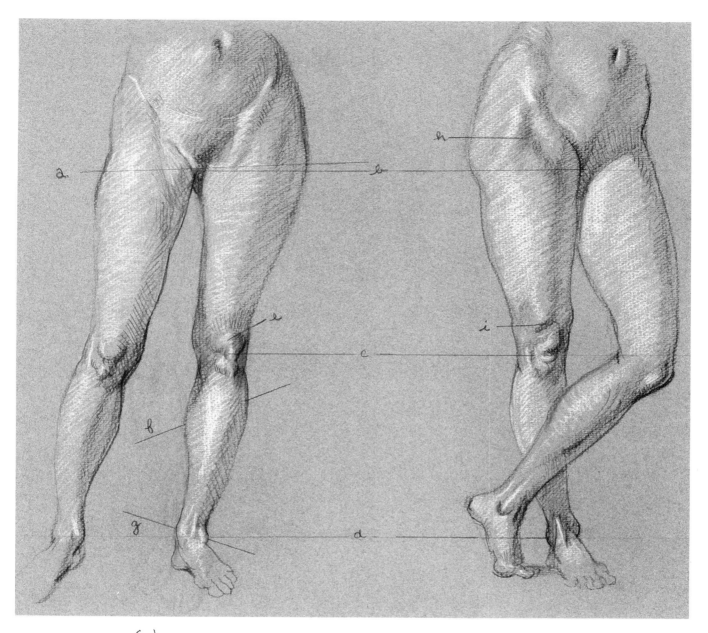

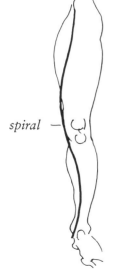

spiral

Above left: *Angle (a) is the midpoint of the body. The kneecap is a round shape that rests on line (c), which is the midpoint between the hipbone (b) and the ankle (d). Beneath the kneecap is another round, fatty shape (e). The outside of the calf is higher than the inside, making angle (f). The inside of the ankle is higher than the outside, forming the opposite angle (g). Starting with the hipbone, a muscle runs obliquely across the leg down to the inside of the knee. A spiral line is formed by continuing down the shinbone of the lower part of the leg to the inside of the ankle (see diagram at left).*

Above right: *When the leg is tensed, muscles attached to the pelvis make an upside-down V shape (h). The locked knee also causes a depression above the kneecaps (i). The inside of the ankle is farther forward than the outside.*

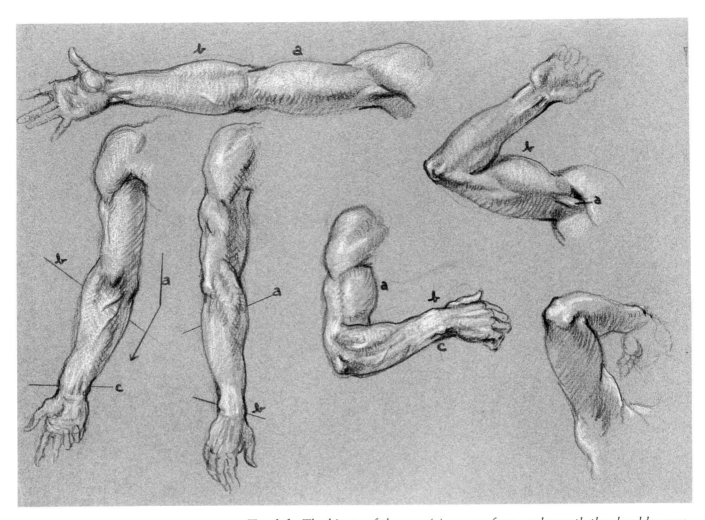

three prominent bones make a triangle

Top left: *The biceps of the arm (a) emerge from underneath the shoulder muscles. The top of the forearm makes a high silhouette (b).*

Lower left: *When the palm of the hand is forward, the forearm angles away from the body (a). The outside of the forearm attaches high above the elbow and creates an angle with the inside (b) that is opposite the angle of the bones at the wrist (c).*

Center left: *When the palm is turned in, the arm straightens and the two angles of the forearm (a) and wrist exchange direction (b).*

Center: *When the arm is bent, the bicep (a) swells and the bones of the elbow protrude. The bone on the thumb side of the wrist (b) is longer than the bone on the little finger side (c).*

Top right: *There is a small muscle (a) in the armpit that is exposed only when the arm is raised. The bicep (b) swells as it raises the arm.*

Lower right: *When the elbow is bent, the bones of the elbow form a triangle (see diagram).*

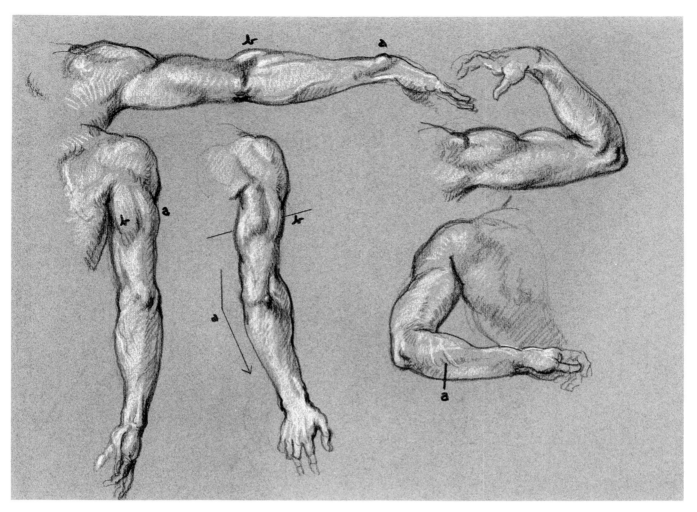

Top left: *The wristbone on the little finger side is very prominent (a). There are two muscles on the top part of the forearm that create the high silhouette (b).*

Lower left: *When the palm is turned in, the arm hangs straight. The muscle on the outside of the upper arm (a) is more prominent and shorter than the one on the inside (b).*

Center: *The lower part of the arm angles out away from the body (a) when the palm faces forward. The outside of the upper arm is higher than the inside (b).*

Top right: *The back muscles extend into the arm. The bicep bulges when it raises the arm.*

Lower right: *The arm is bent behind the torso. The bones of the elbow protrude and a shadow (a) on the forearm indicates the direction of the bone.*

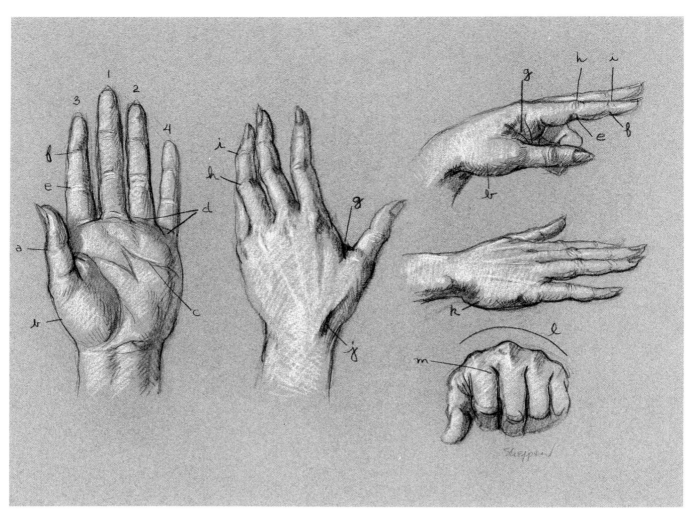

Left: *The palm view of the female hand. The thumb (a) has only two joints; the other fingers have three. The ball of the thumb (b) sits separate from the rest of the hand. Folds in the palm (c) create the letter M. The fingers are numbered here in order of their length. Folds (d) are created on the palm where the fingers bend: The two middle fingers have two folds; the little finger and the index finger have one fold. Joint e has two folds and joint f has one fold.*

Center: *The back of the hand. Knuckle i has smooth creases and knuckle h has fleshy folds of skin. The muscle that pulls the thumb across the hand (g) is attached on the palm side.*

Top right: *The thumb side of the hand.*

Middle right: *The little finger side of the hand. The muscles form a long pad on the little finger side (k).*

Bottom right: *The fist. An arch is formed (l) when the hand is made into a fist; the middle finger knuckle is the highest point. The creases from the middle finger point outward (m).*

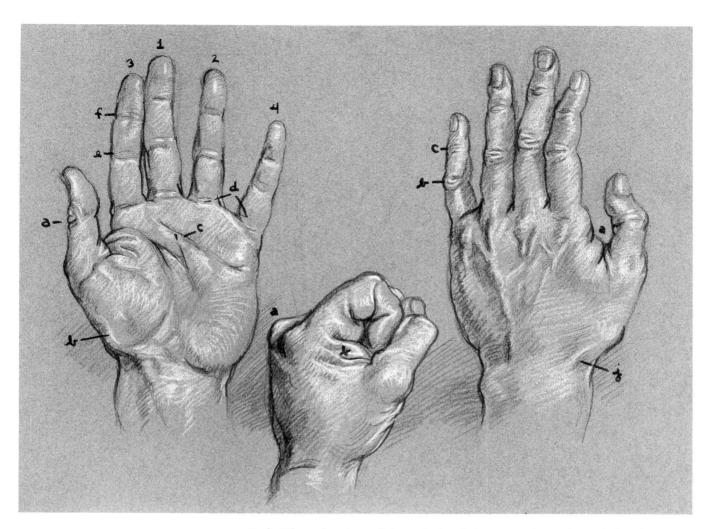

Left: *The palm view of the male hand. In comparison, the male hand is not as graceful or soft as the female's. It tends to look more square, while the female hand appears longer and more narrow. The thumb (a) has only two joints. The ball of the thumb (b) is separate from the rest of the hand. Folds in the palm (c) create the letter M. The fingers are numbered here in order of their length. Folds (d) are created on the palm where the fingers bend: The two middle fingers have two folds; the little finger and the index finger have one fold. The second joint (e) has two folds and the upper joint (f) has one fold.*

Center: *The middle knuckle (a) is longest. Folds are created from the muscles (b) that draw the thumb across the hand.*

Right: *The back of the hand. Knuckle c has smooth creases and knuckle b has fleshy folds of skin. The muscle that pulls the thumb across the hand (a) is attached on the palm side. There is a small triangular depression, caused by tendons to the thumb, called the "snuff box" (j).*

THE STANDING FIGURE

IV

When the standing figure is drawn there is less use of foreshortening than in most other poses, enabling the artist to use the standard eight-heads measurement easily.

There are three basic ways a figure can stand: with all the weight on one leg and balanced with the other, with the weight evenly distributed on both legs, or with the weight on one leg and the other leg raised.

When the weight is on one leg, it throws the hip on that side higher than the other. The shoulders then usually balance the figure by making an opposite angle, giving the figure the classic contrapposto stance. When the weight is equal on both legs, the shoulders are usually straight across.

The kneecap is round, like a silver dollar, and beneath it is a similar fatty shape. The outside of the calf makes a smoother but higher silhouette than the inside, creating an angle from the outside down to the inside. The ankle has an opposite angle (see diagram at left).

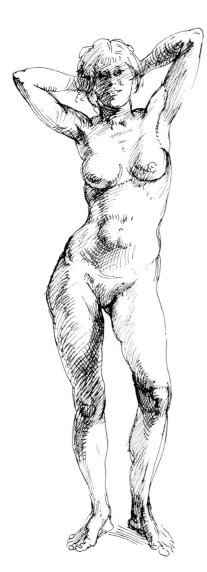

Above: *The neck sits into the center of the torso, with the shoulder muscles in back of it and the collarbones in front. The second rib attaches to the breastbone and shows as a horizontal line across the chest. Fat over the pelvic ridge makes the waist higher on women than on men.*

Right: *On the left thigh, a shadow from a muscle descends down to the inside of the knee and makes a continuous spiral down the edge of the shinbone to the inside of the ankle (see diagram far right). The inside of the ankle is always higher than the outside.*

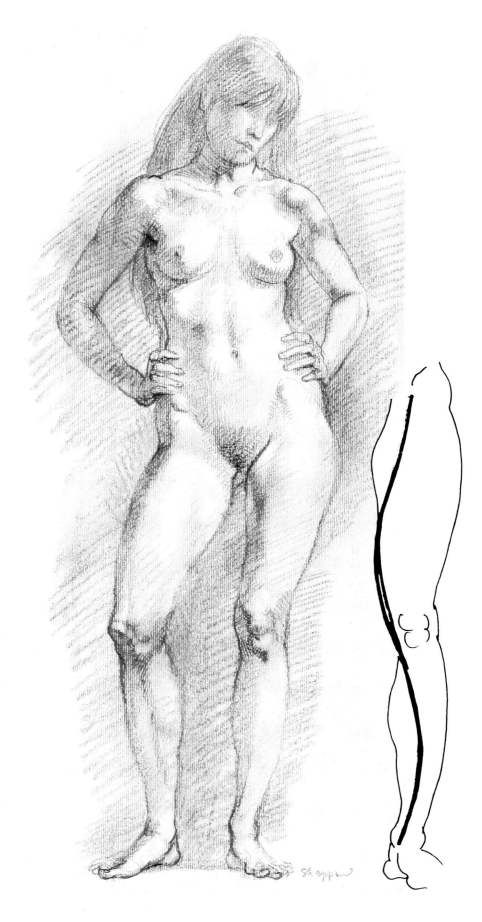

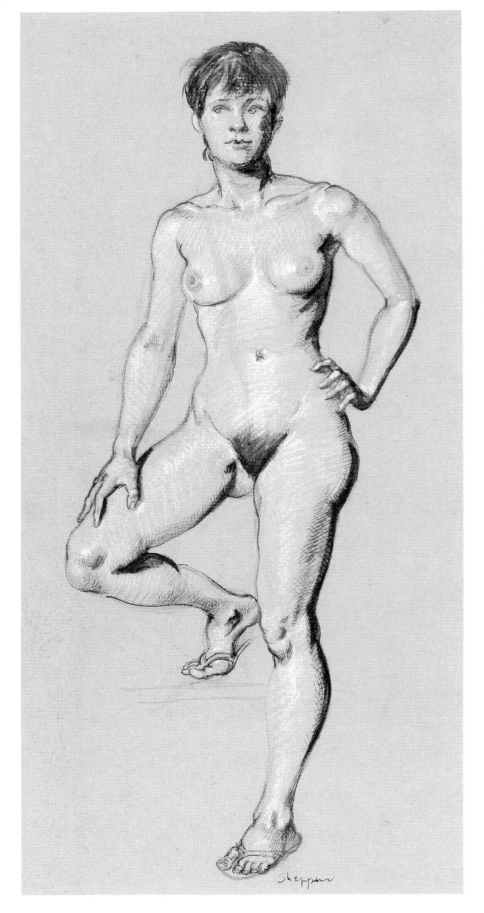

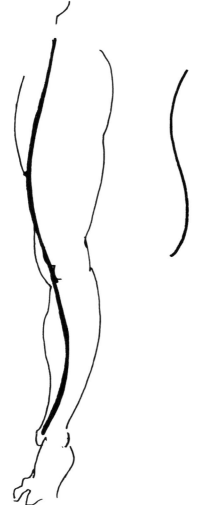

The left leg is locked, pushing the knee back. This puts the leg in an S shape (see diagram below). The outside of the right forearm rises above the elbow, which is prominent on the inside of the arm.

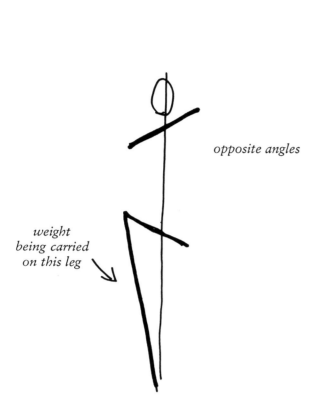

opposite angles

weight
being carried
on this leg

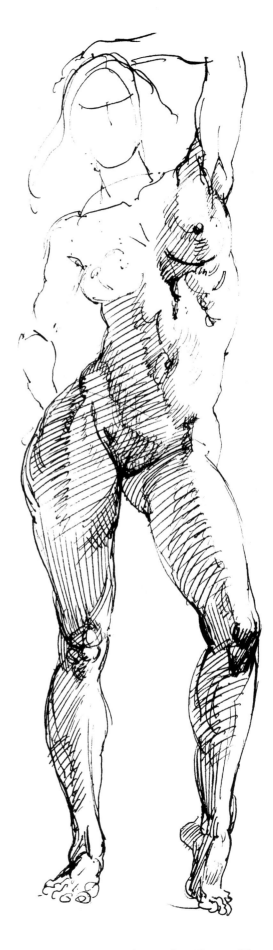

The weight of the torso is on the right
leg, which forces the right hip higher
than the left. The left leg is used to
balance the figure. The shoulders
slant in the opposite direction from
the hips. This attitude is called con-
trapposto (see diagram above).

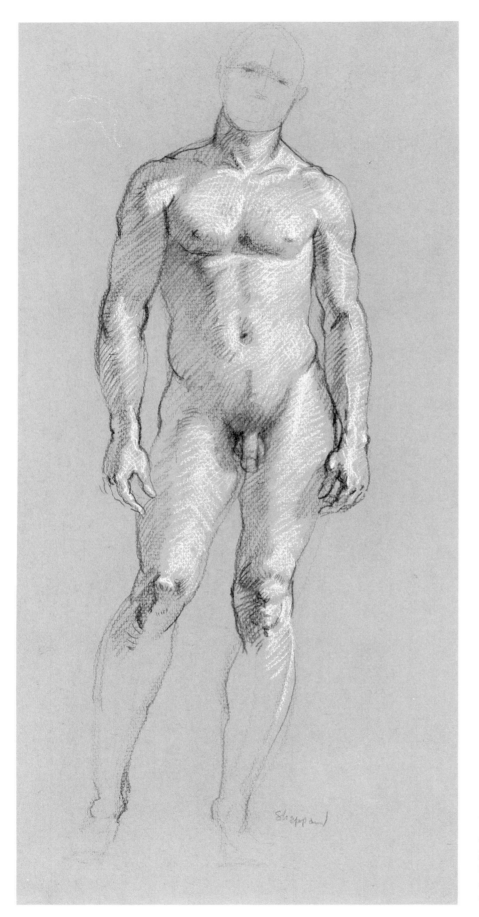

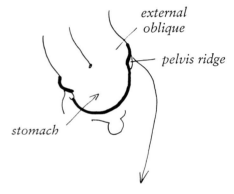

external
oblique

pelvis ridge

stomach

The model's weight is on his left leg
and his shoulders and hips are at op-
posite angles. The external oblique
muscles overlap the pelvic ridge and
the stomach fits down into the basin
of the pelvis (see diagram).

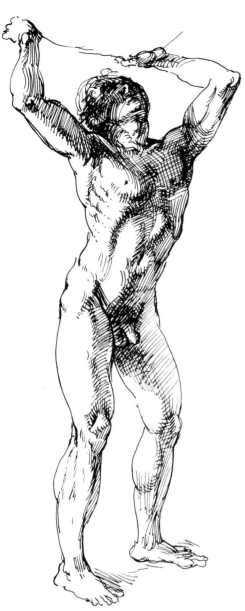

When the arms are raised, the serratus muscles show like fingers connecting to the ribs. Muscles attaching from the pelvis form an upside-down V shape on the upper part of the thigh.

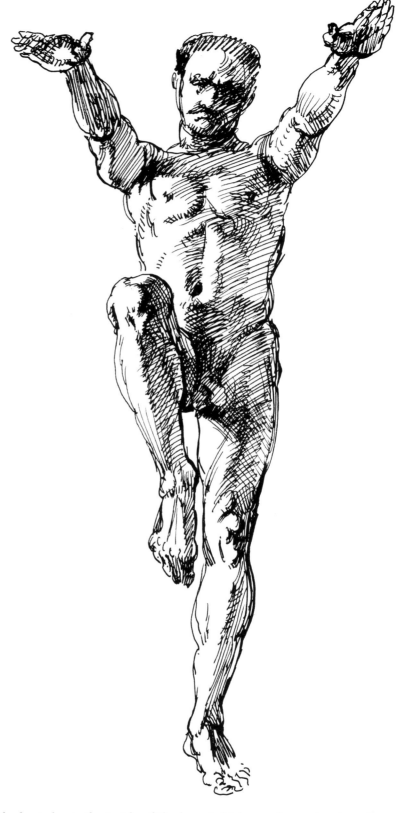

When the leg is bent, the inside of the knee is higher and rounder than the outside. The kneecap is prominent and the shape of the ridge of bone beneath it is triangular. The foreshortened arms are mostly explained by overlapping lines.

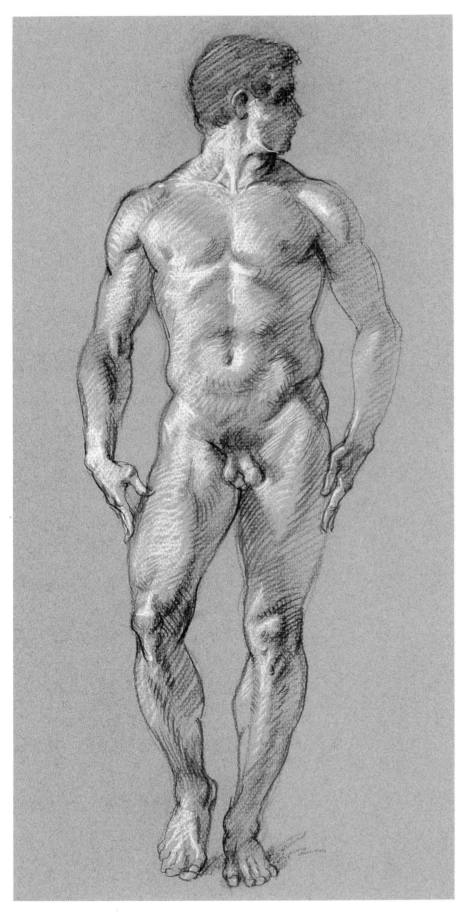

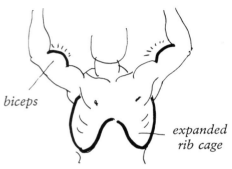

biceps

expanded
rib cage

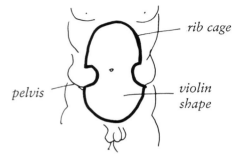

rib cage

pelvis

violin
shape

A large violin shape is created on the
front of the torso by the hollow of the
rib cage and the ridge of the pelvis.
The inside of the ankle is higher than
the outside and at the knee the out-
side of the lower leg is higher than the
inside (see diagrams above).

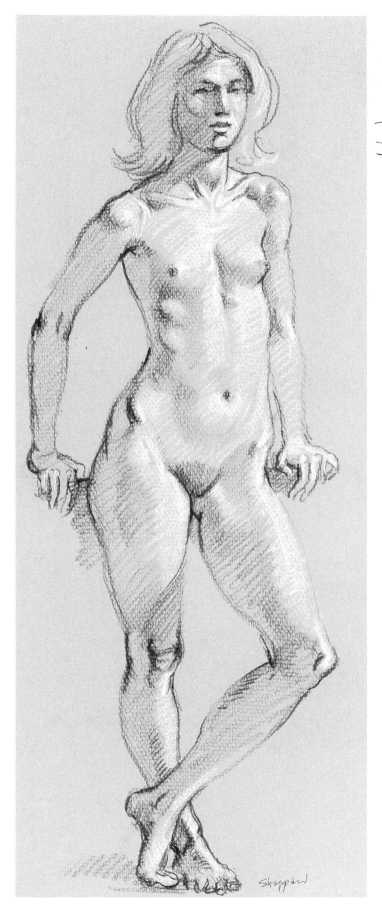

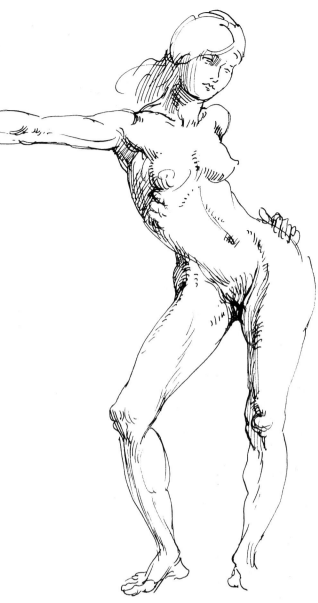

Above: *The chest muscles go out into the arms and form the front wall of the armpit. The breasts rest on top of these muscles. The inside of the thigh is divided from the front by a diagonal muscle running from the pelvis down to the inside of the knee.*

Left: *The collarbones start at the base of the neck and angle back and out toward the tips of the shoulders. There are muscles that start behind each ear and angle down to the middle of the front of the neck and attach between the collarbones, forming a V shape.*

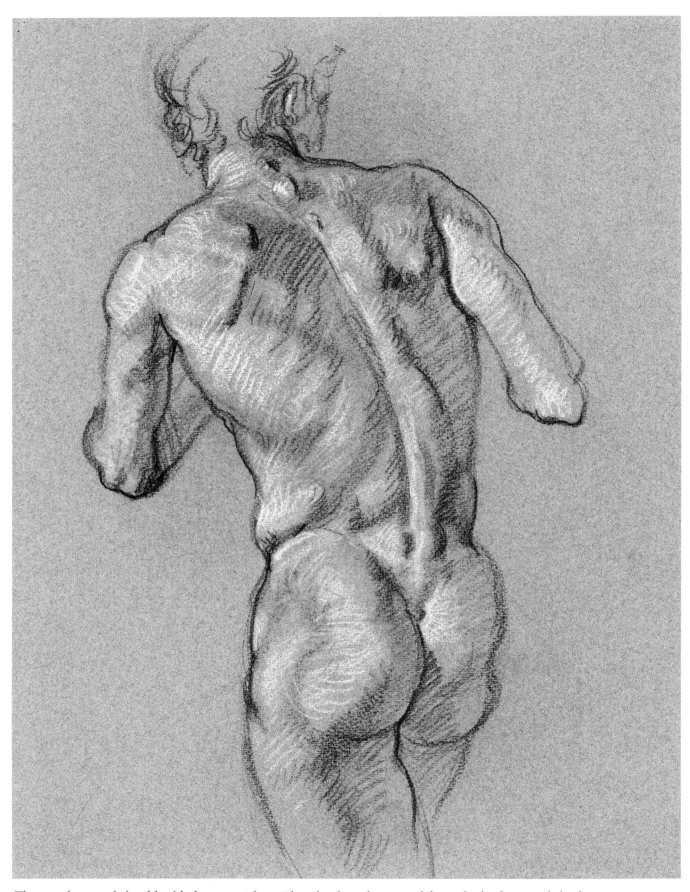

The vertebrae and shoulder blades are evident. The ribs slant downward from the back toward the front.

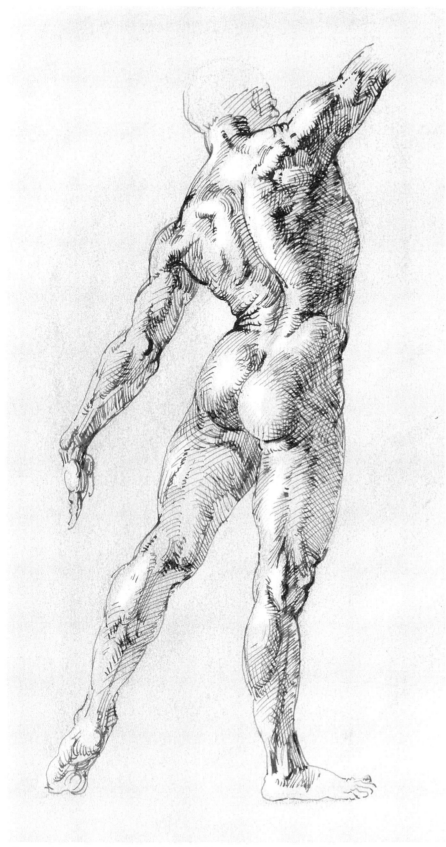

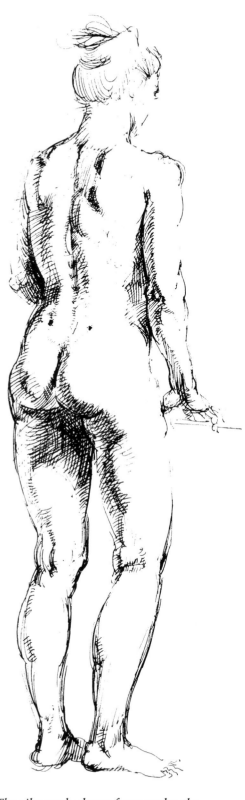

The angle of the shoulder blades follows the arms. The large trapezius muscle attaches to the top of the shoulder blades and into the base of the back of the head.

The ribs angle down from under the shoulder blades toward the front of the body. Beneath the buttocks there are fat deposits. The bone on the little finger side of the wrist is more prominent than the one on the thumb side.

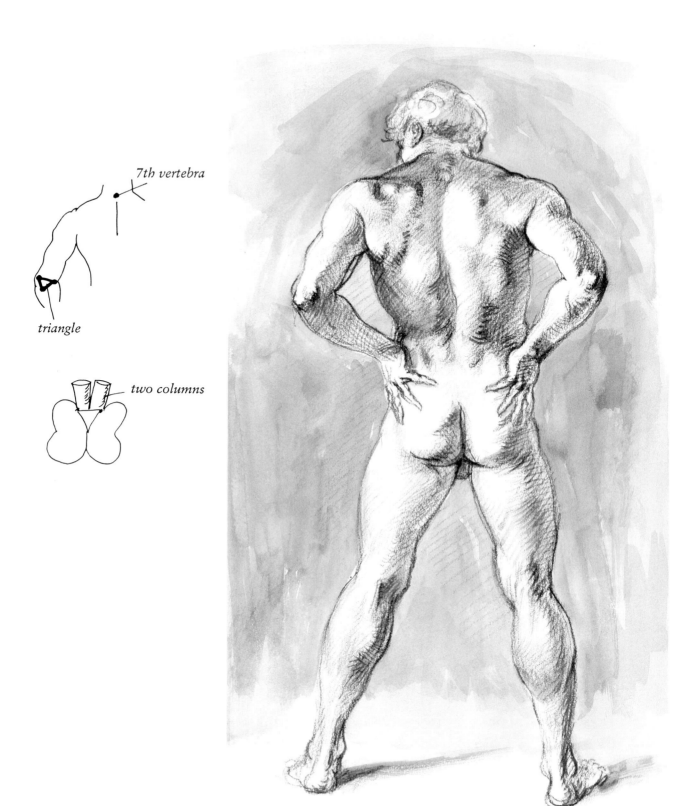

7th vertebra

triangle

two columns

Two columns of muscles form above the pelvis. The bent elbow forms a triangular shape and the seventh cervical vertebra shows on the back of the neck (see diagrams).

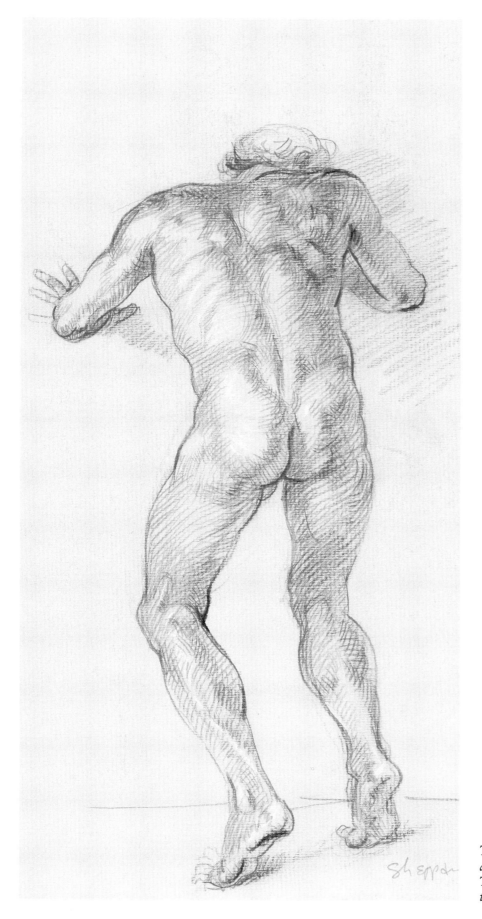

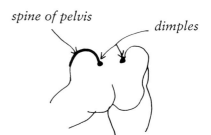

spine of pelvis dimples

The calves of the leg flex and harden as the model pushes against the wall. Two dimples form from the flanges of the pelvis (see diagram).

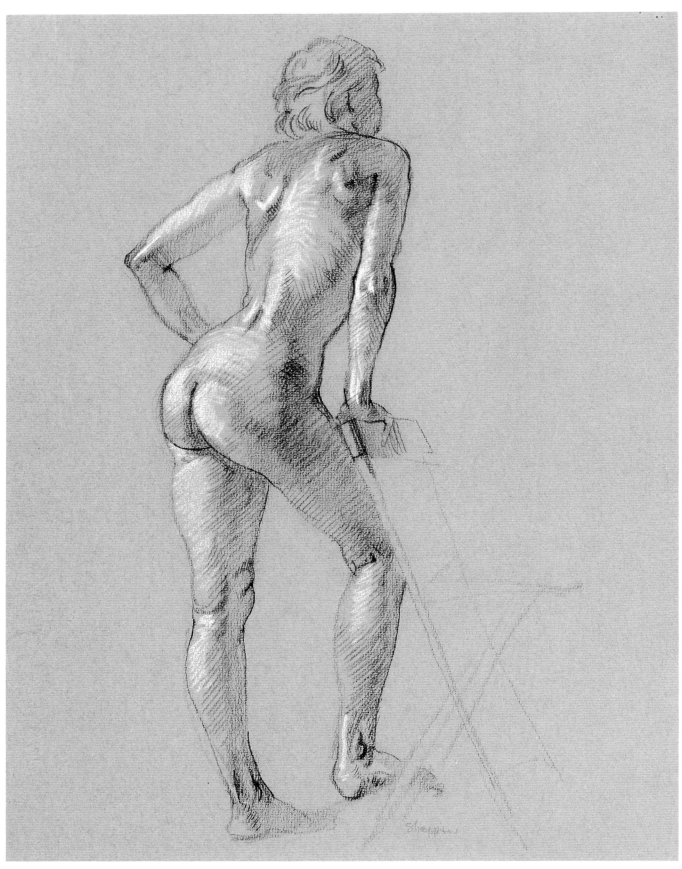

The weight of the figure is evenly distributed between the supporting leg and the chair, balancing the center of gravity between the two supports. The upward angle of the ribs is quite evident.

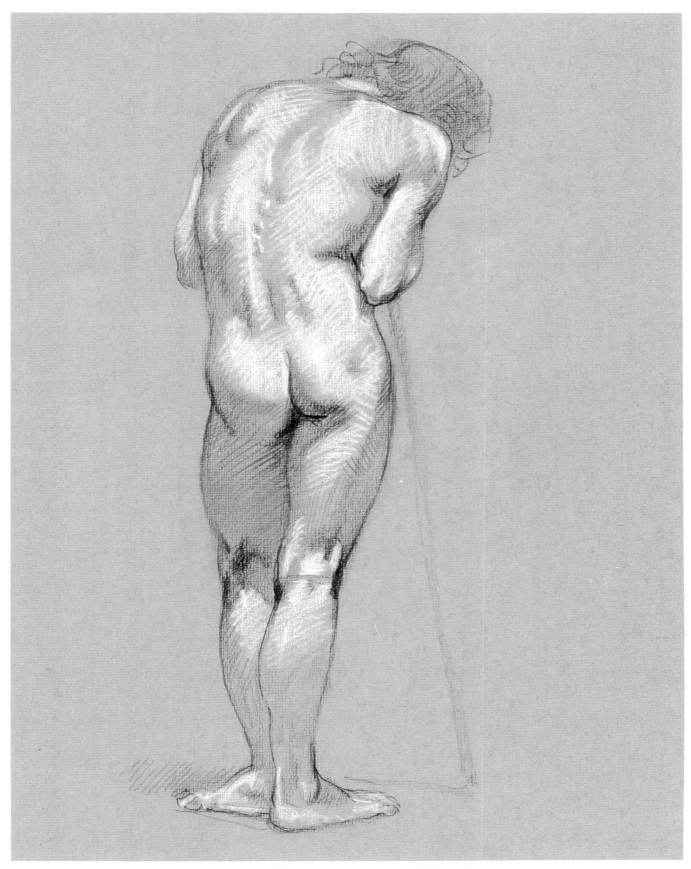

An S curve can be traced through the curve of the spine and down the right leg. The columns of muscle on either side of the lower spine are visible. The left shoulder dips down to counter the upward thrust of the right hip.

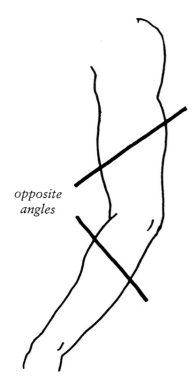

opposite
angles

Right: *The wrist forms a flat plane between the bones of the forearm and the hand. The silhouettes of the upper arm and forearm form opposite angles (see diagram above).*

Above: *The arm begins with the shoulder blade. The outside of the forearm connects above the elbow. The left leg angles in under the torso to help support the weight of the body.*

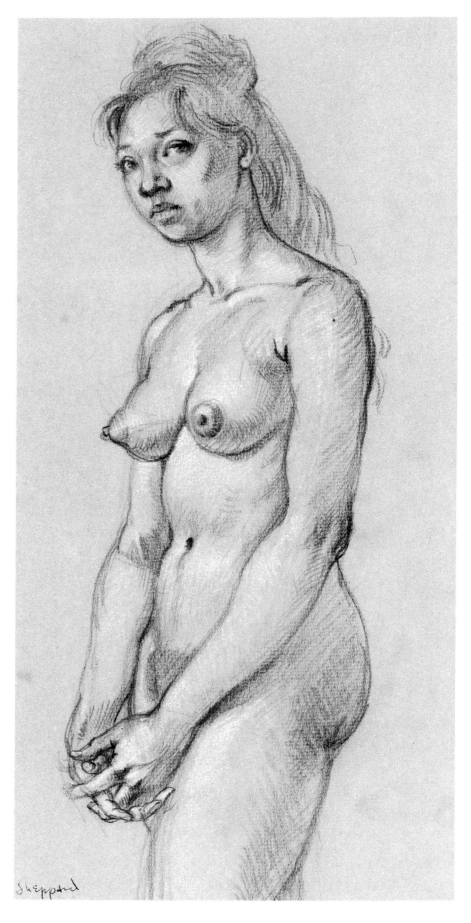

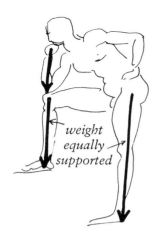

weight
equally
supported

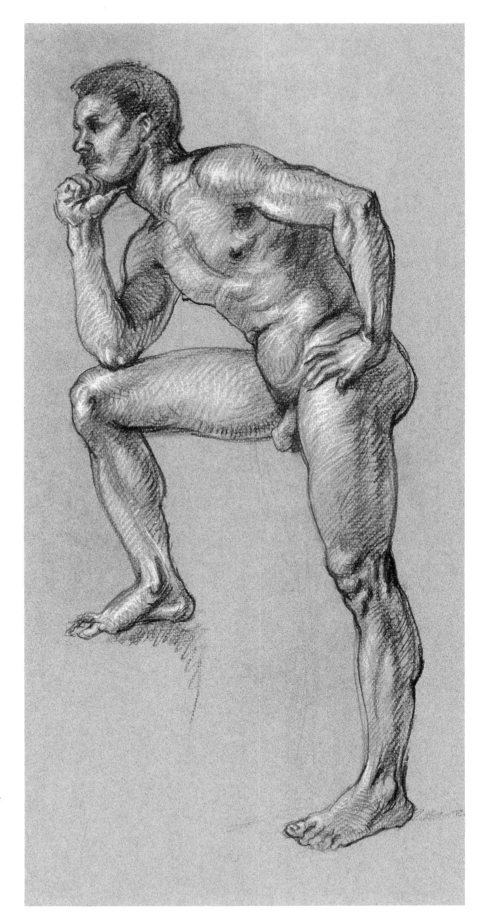

Two large muscles form the inside of the calf. The arch on the inside of the foot is evident. Body weight is evenly distributed between the left leg and the continuing line between the right forearm and right lower leg (see diagram).

THE SEATED FIGURE
V

M ost seated figures end up measuring six heads high: four for the torso and two for the part of the leg that is not foreshortened.

The weight of the figure usually rests on the buttocks and thighs, flattening them out.

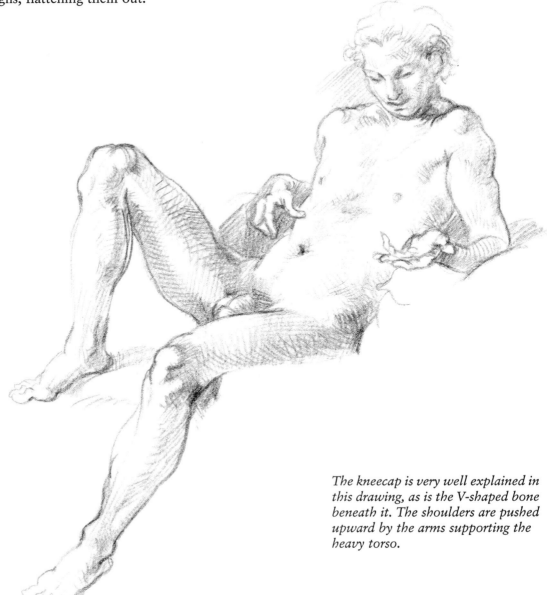

The kneecap is very well explained in this drawing, as is the V-shaped bone beneath it. The shoulders are pushed upward by the arms supporting the heavy torso.

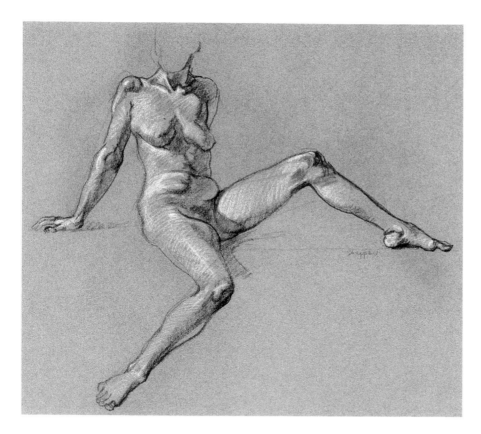

Locked arms support the leaning torso and push the shoulders high and forward. The collarbones go behind the shoulders. Folds on the belly are caused by the raised leg.

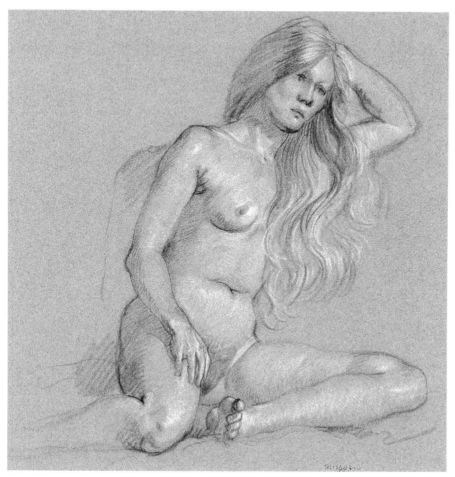

The softness of the thighs and belly is typically female. The bones are less evident than in the male, except in the knees, wrists and elbows.

45

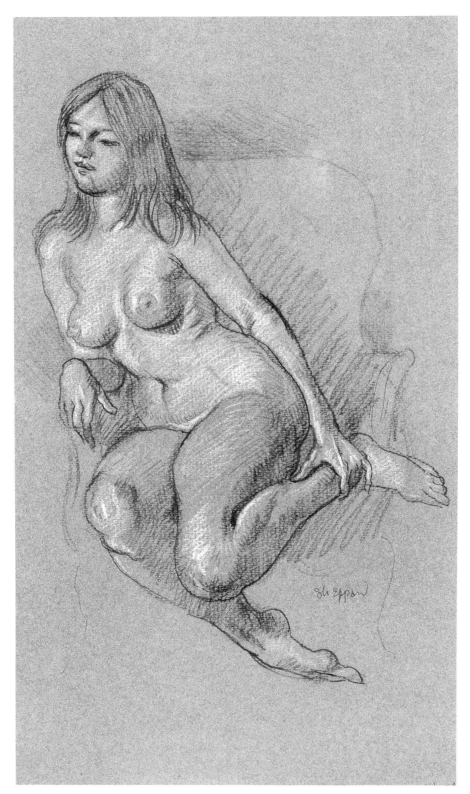

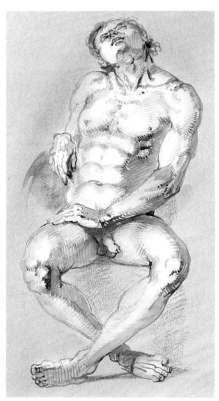

This is a watercolor wash and chalk on white paper. Here color must be worked around the highlights, leaving the white of the paper to do the job. The foreshortened legs are defined by overlapping contour lines.

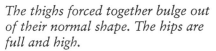

The thighs forced together bulge out of their normal shape. The hips are full and high.

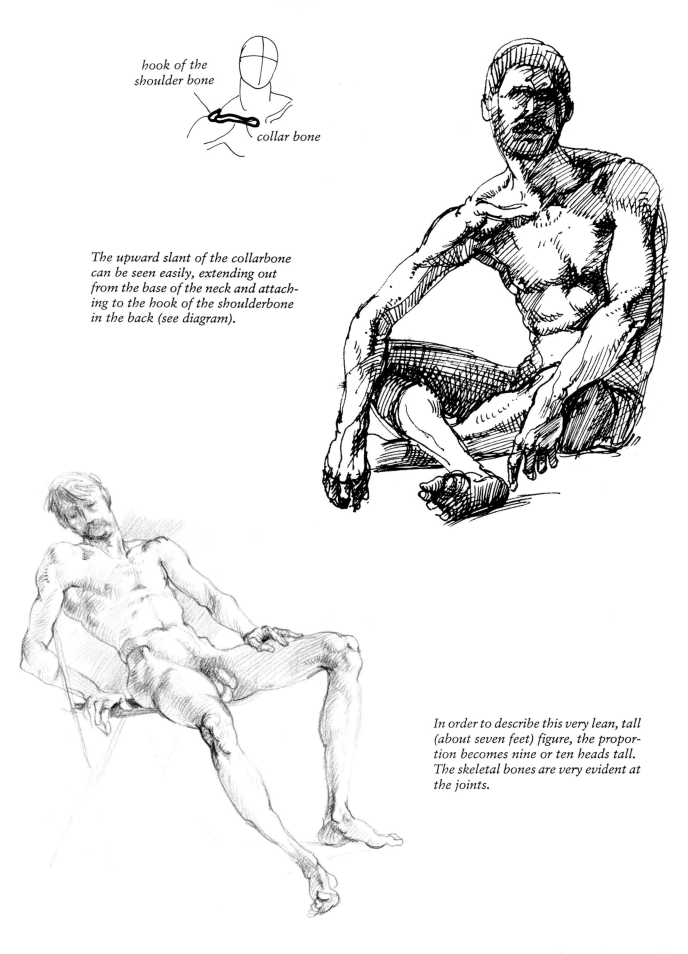

hook of the
shoulder bone

collar bone

The upward slant of the collarbone
can be seen easily, extending out
from the base of the neck and attach-
ing to the hook of the shoulderbone
in the back (see diagram).

In order to describe this very lean, tall
(about seven feet) figure, the propor-
tion becomes nine or ten heads tall.
The skeletal bones are very evident at
the joints.

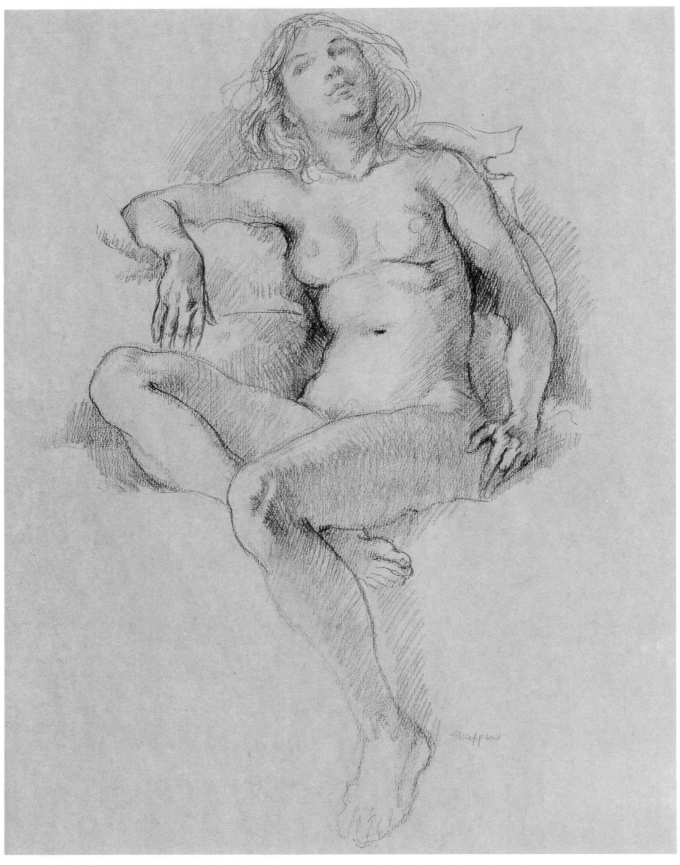

Integrating the figure's contours with the edges of the cushion reveals the distribution of weight in repose. The soft curves of the body and the lack of muscles sharply defined by contraction enhance the relaxed mood of the drawing.

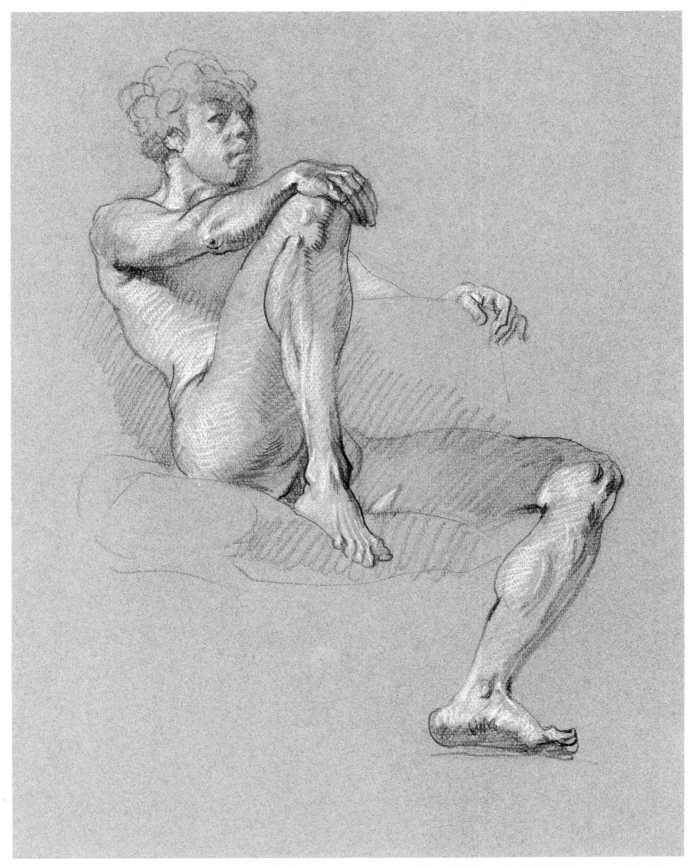

Seeing the underside of the left foot, along with the intersecting contour lines, helps make the left leg appear foreshortened. A dark accent around the right ankle pushes it to the foreground.

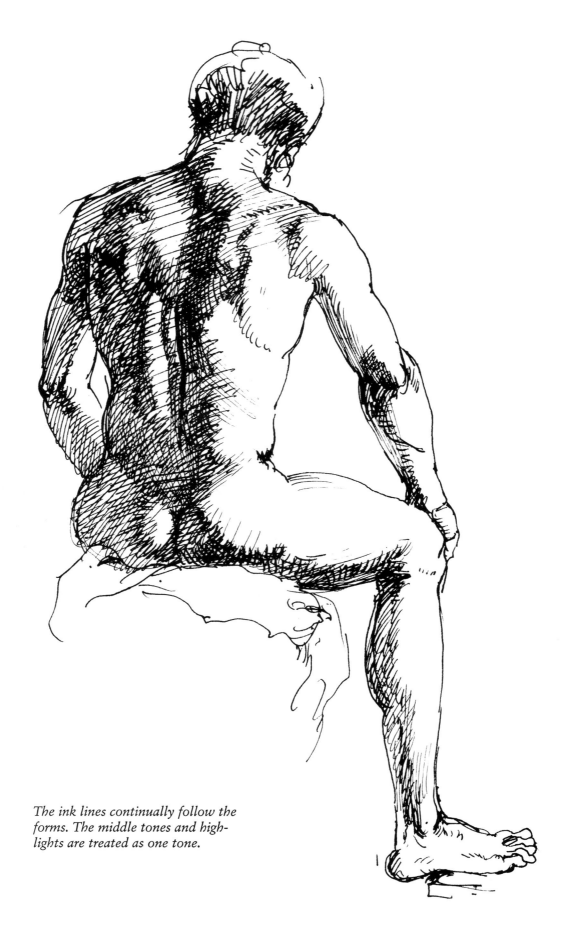

The ink lines continually follow the forms. The middle tones and highlights are treated as one tone.

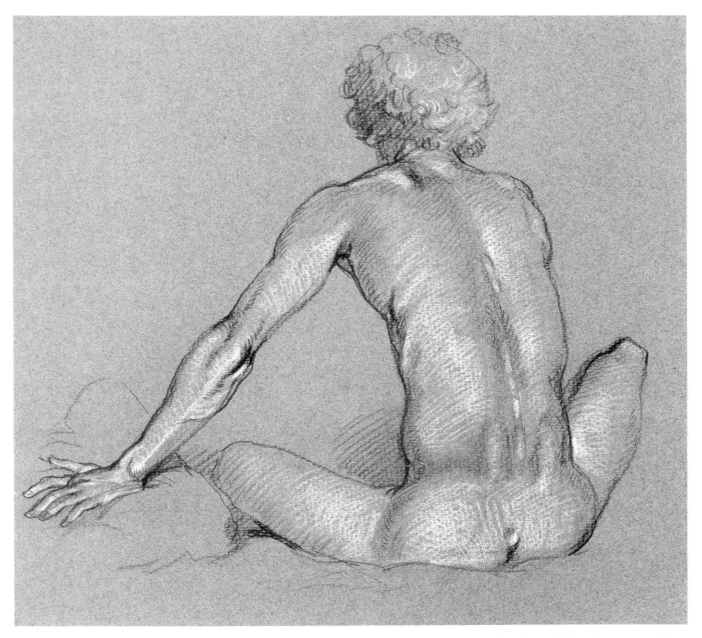

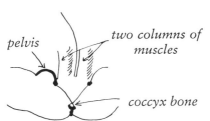

pelvis

two columns of muscles

coccyx bone

At the base of the spine, part of the pelvis called the coccyx (the beginning of the inverted human tail) protrudes. The spine pushes against the skin as the torso leans forward. Two vertical columns of muscles start at the end of the pelvis and extend up into the back along the spine (see diagram).

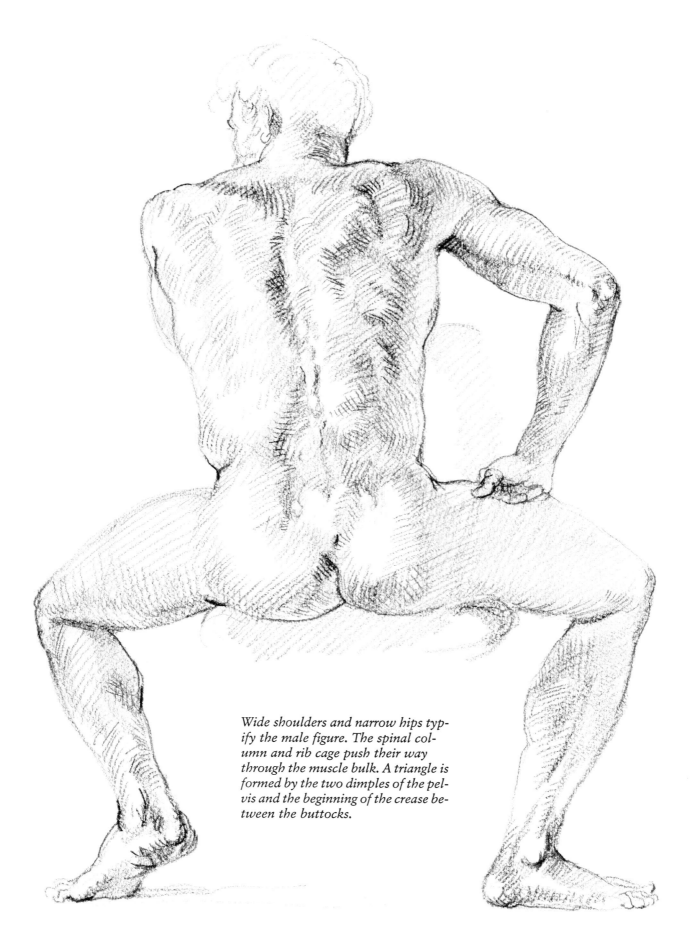

Wide shoulders and narrow hips typify the male figure. The spinal column and rib cage push their way through the muscle bulk. A triangle is formed by the two dimples of the pelvis and the beginning of the crease between the buttocks.

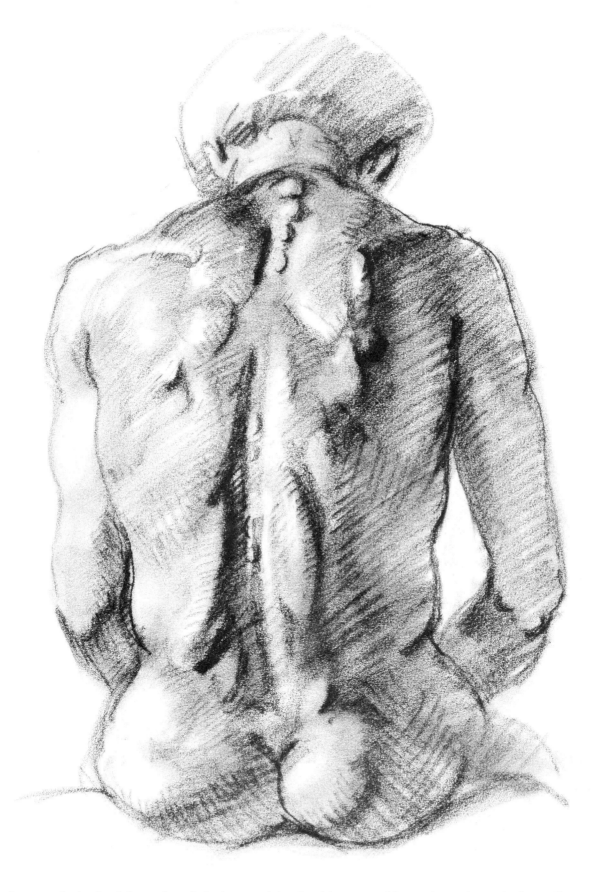

The vertebrae on the back of the neck and the bones of the shoulder are visible on the surface. The bent elbows make the bones create triangular shapes.

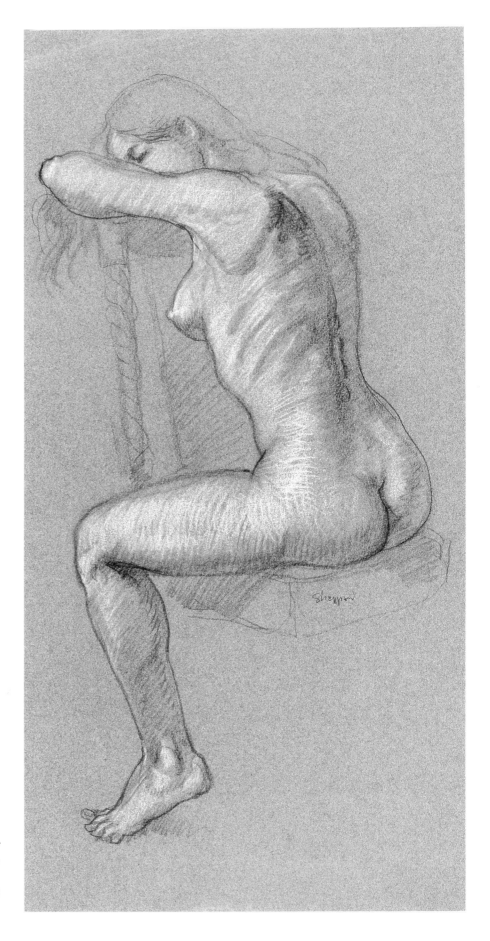

The muscles attached to the shoulder blade extend into the arm. The vertebrae show down the center of the back. The ribs slant diagonally down toward the front.

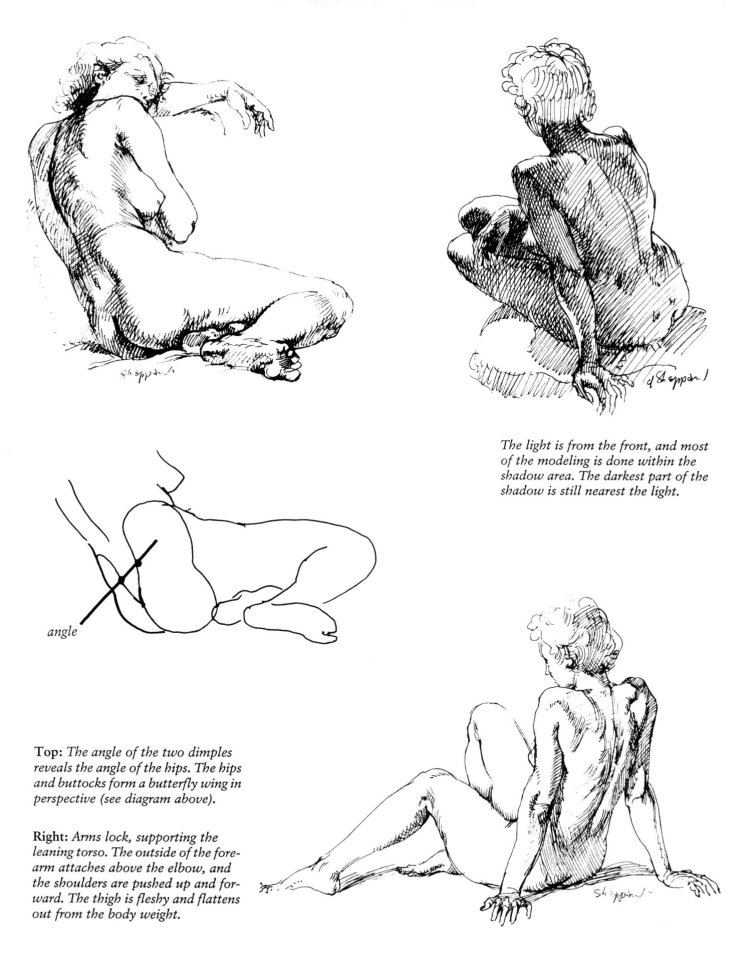

The light is from the front, and most of the modeling is done within the shadow area. The darkest part of the shadow is still nearest the light.

angle

Top: *The angle of the two dimples reveals the angle of the hips. The hips and buttocks form a butterfly wing in perspective (see diagram above).*

Right: *Arms lock, supporting the leaning torso. The outside of the forearm attaches above the elbow, and the shoulders are pushed up and forward. The thigh is fleshy and flattens out from the body weight.*

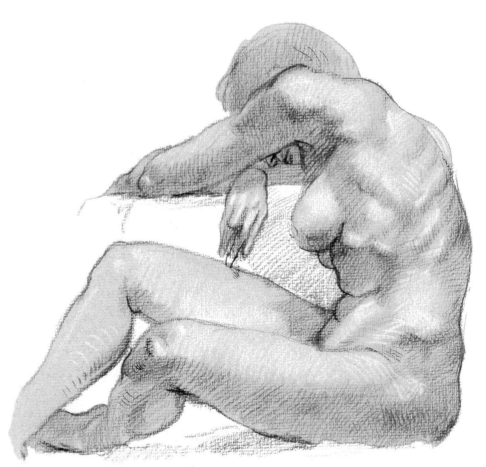

Left: *The shoulder muscles form a pad that encircles the ball-and-socket joint of the shoulder. The egg-shaped mass of the rib cage is clearly visible. The crest of the pelvis and the head of the hipbone can be seen beneath the surface.*

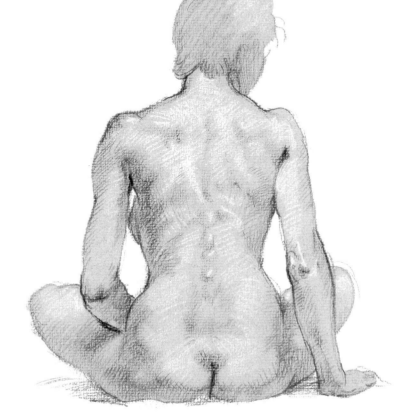

Right: *The ridges of the vertebrae can be seen in the valley between the muscles. The tailbone forms a triangular arrangement with the dimples at the base of the spine. The muscles and fat form a butterfly shape at the base of the torso and the buttocks.*

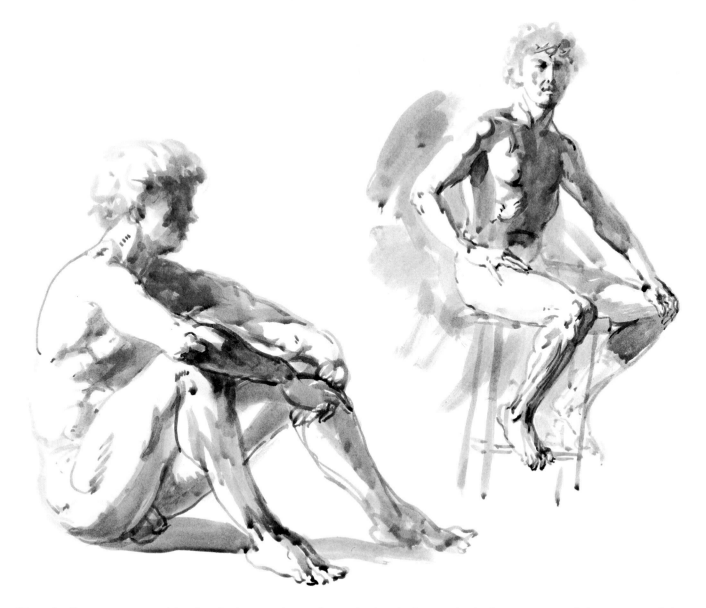

Here the figure is suggested by the shadow washes only. Only the shadow and a little suggestion of the contour of the light side were drawn and the figure began to take form.

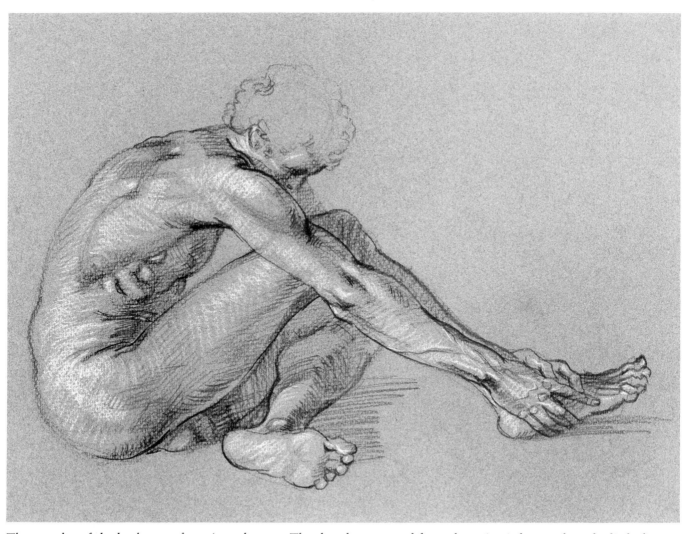

The muscles of the back extend out into the arm. The thumb, measured from the wrist, is longer than the little finger side of the hand. At the wrist, there is a short flat space between the two bones of the arm and the hand.

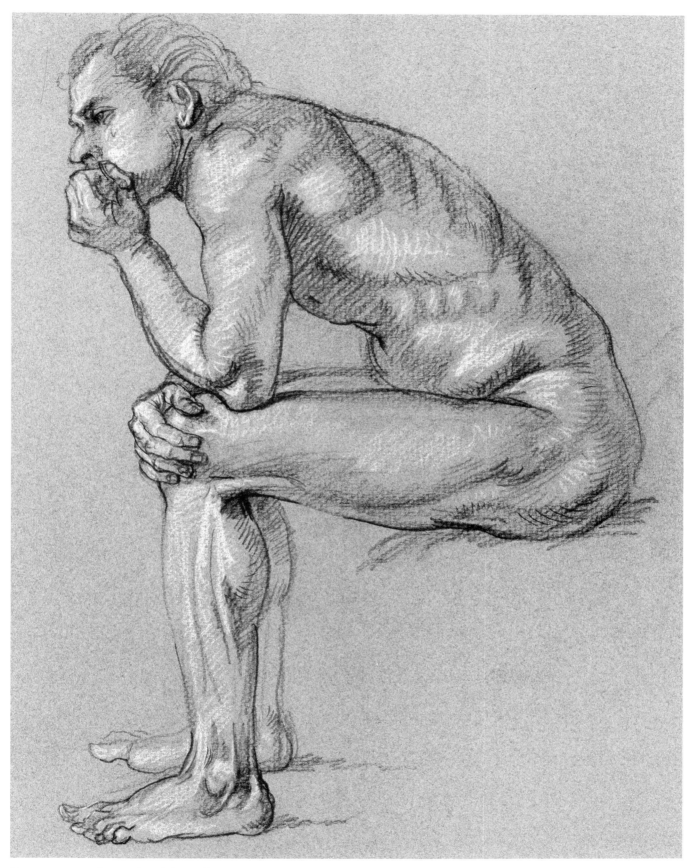

In contrast to the inside of the calf, the outside has several long, thin muscles that run down it to the foot. The belly hangs relaxed as the torso leans forward.

THE KNEELING FIGURE

VI

The weight of a kneeling figure is on one or both knees, and sometimes the elbows or hands. A kneeling figure is six heads tall, with the lower part of one leg prone to the supporting surface. Usually this leg is foreshortened. Kneeling figures can be very dramatic and expressive, and are well worth study.

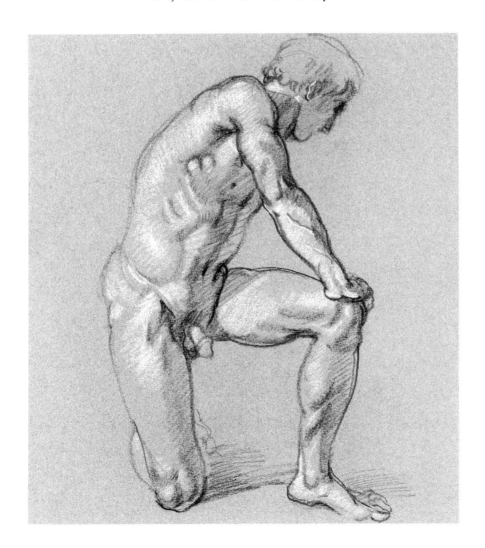

The full muscle above the pelvic crest is called the external oblique. The serratus muscles attach to the downward slanting ribs and can be seen beneath the armpit. The bone on the inside of the elbow is always prominent.

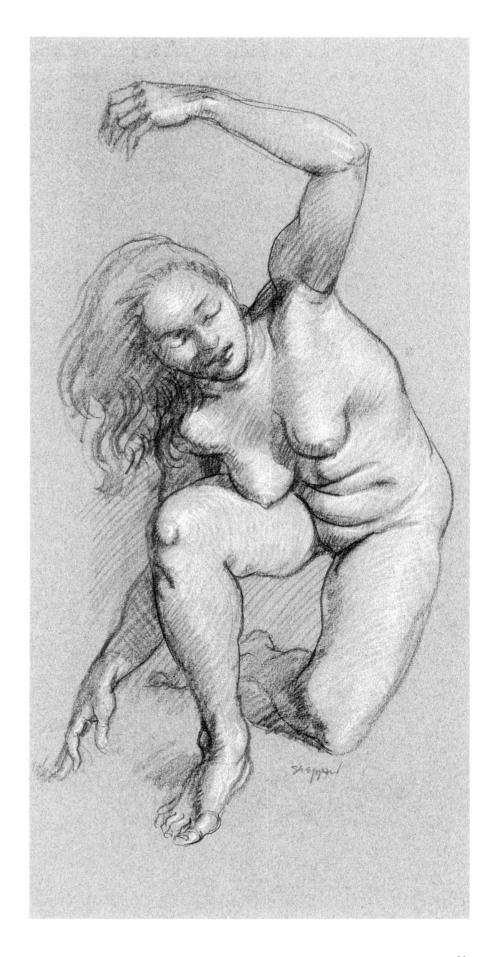

The weight is supported on the left knee and the right fingertips. The right arm is used as a balance. The cast shadow thrown from the right knee projects the knee forward.

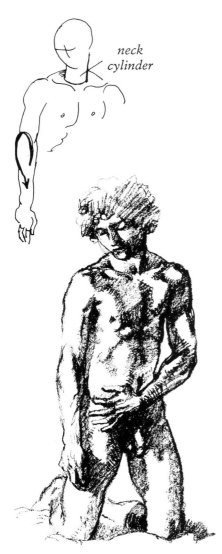

neck
cylinder

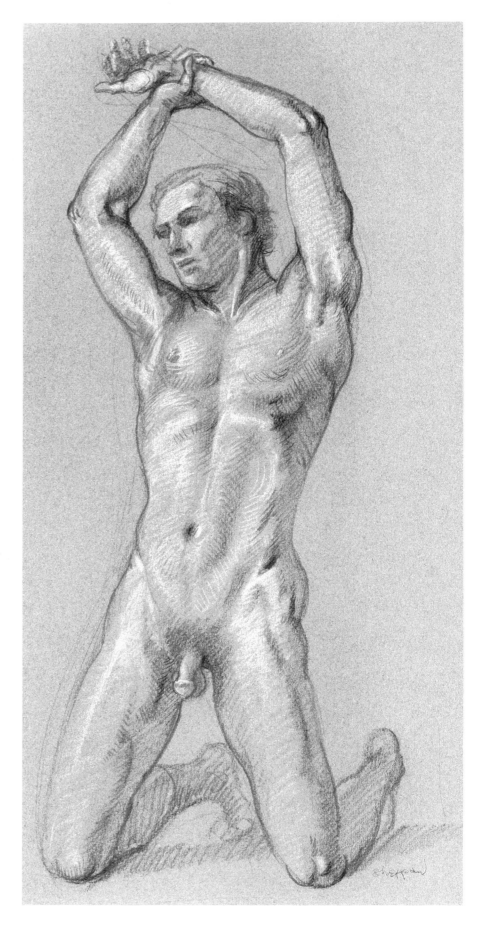

Above: *The muscles on the outside of the elbow start high up in the upper arm and cross over and down toward the thumb side of the wrist. The neck cylinder fits down between the back shoulder muscles and the two collarbones in front (see diagram).*

The chest muscle or pectoralis pulls up into the arm and creates the front wall of the armpit. Next to the pectoralis, just above the armpit, is a small muscle called the coracobrachialis that only shows when the arm is raised. The large muscle from the base of the neck to the back of the ear is the sternomastoid.

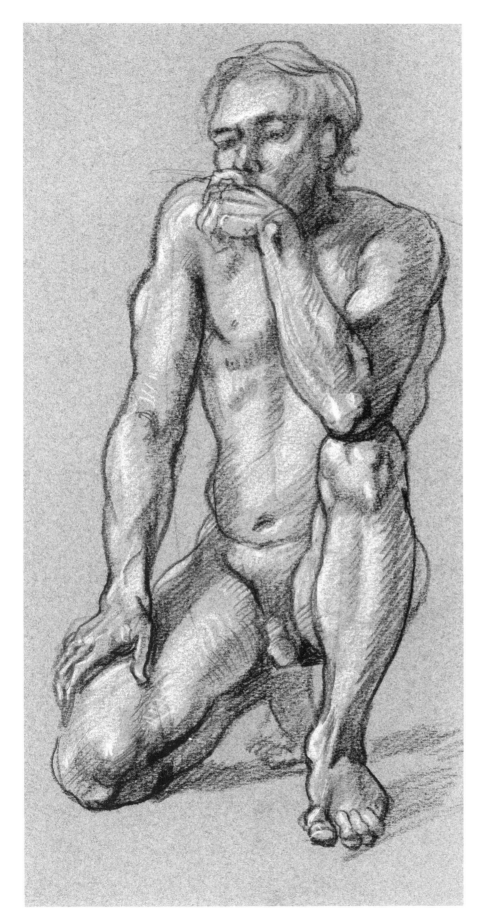

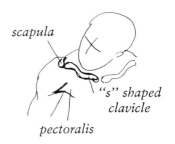

scapula

"s" shaped clavicle

pectoralis

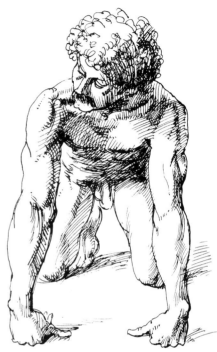

Above: *The clavicles or collarbones angle back from the front of the base of the neck in an S shape and meet the end of the scapulas (see diagram above). The pectoralis or chest muscles extend out into the arms.*

kneecap shaped like a lollypop

The kneecap and its ligament are shaped like a lollipop on a stick. The edge of the large bone of the lower part of the leg descends downward to the inside ankle (see diagram).

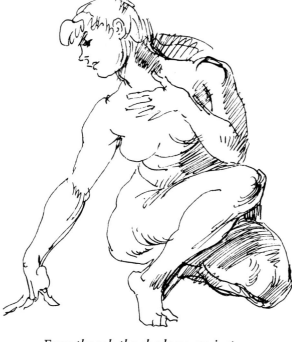

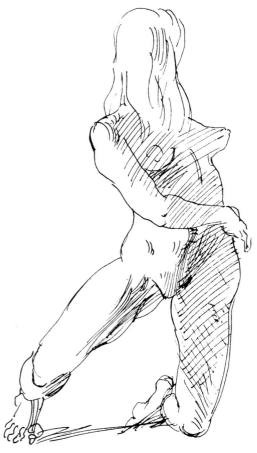

Even though the shadows are just scribbled in, they still indicate the volume of the figure and the angle of the light source.

An unseen arm balances the figure. Some of the best poses are difficult to hold, so an artist must get the information down quickly.

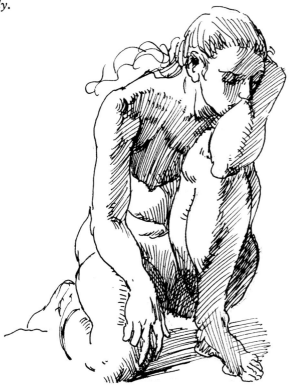

The arch is prominent on the inside of the foot. The shadow accents follow the direction of the form.

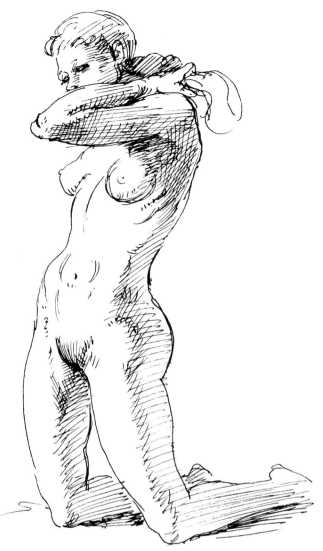

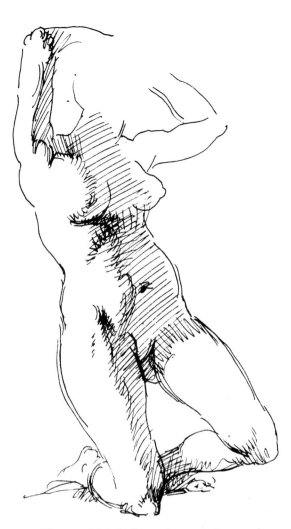

The head and belly are forward to balance the arched back. Bones are obvious in the elbow, ribs, pelvis and knees.

The model is balanced on one knee and one foot. A pose like this must be drawn quickly. The shadow accent indicates the arch of the rib cage and the ridge of the pelvis.

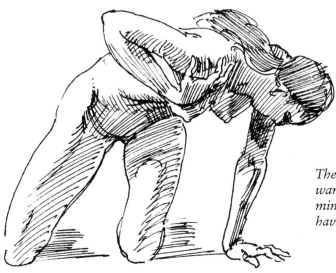

The weight of the figure is thrown forward onto the left arm. In this two-minute sketch, the light and shadow have been roughly indicated.

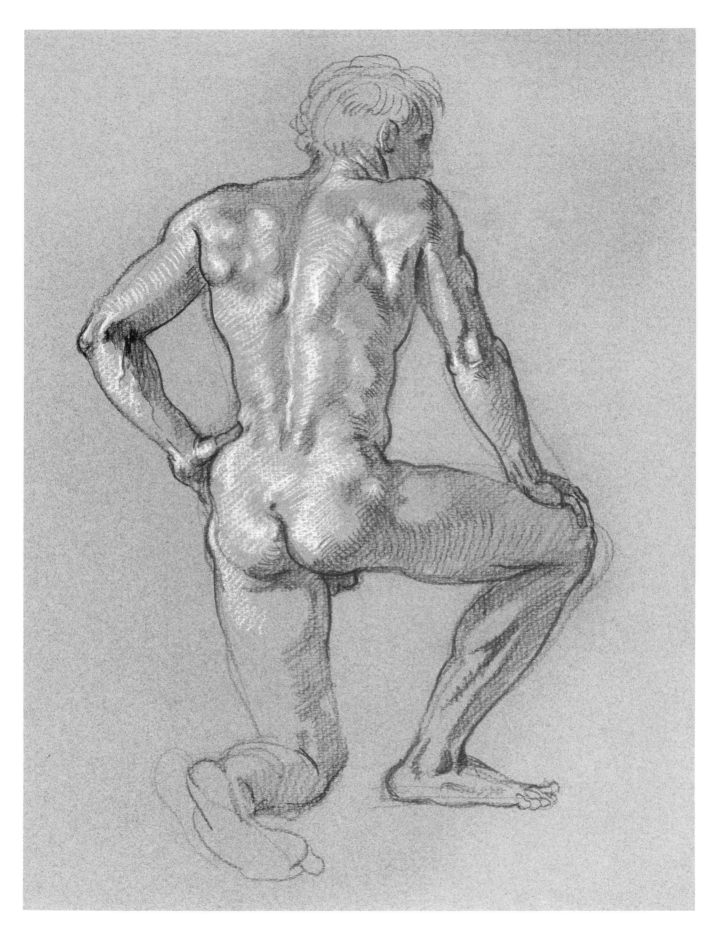

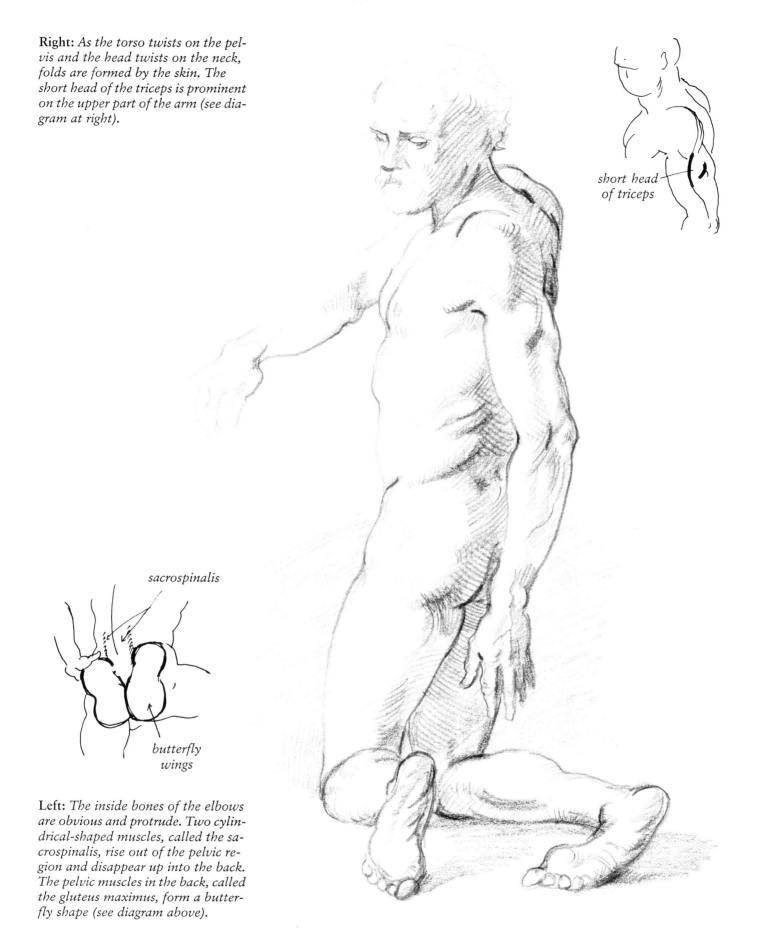

Right: *As the torso twists on the pelvis and the head twists on the neck, folds are formed by the skin. The short head of the triceps is prominent on the upper part of the arm (see diagram at right).*

short head
of triceps

sacrospinalis

butterfly
wings

Left: *The inside bones of the elbows are obvious and protrude. Two cylindrical-shaped muscles, called the sacrospinalis, rise out of the pelvic region and disappear up into the back. The pelvic muscles in the back, called the gluteus maximus, form a butterfly shape (see diagram above).*

The large muscle that forms the back
of the shoulders is called the trape-
zius. It starts at the base of the skull
and descends out to the tip of the
shoulder blades, forming the silhou-
ette of the shoulders (see diagram).

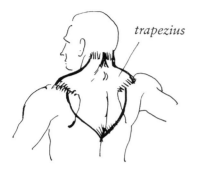

trapezius

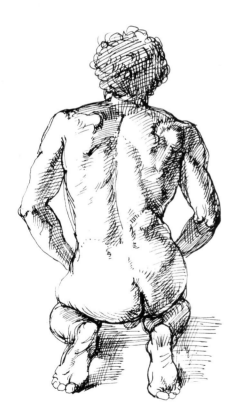

The two shoulder blades are clearly
marked, as are the two dimples from
the pelvis. The shoulders and pelvis
are at opposite angles.

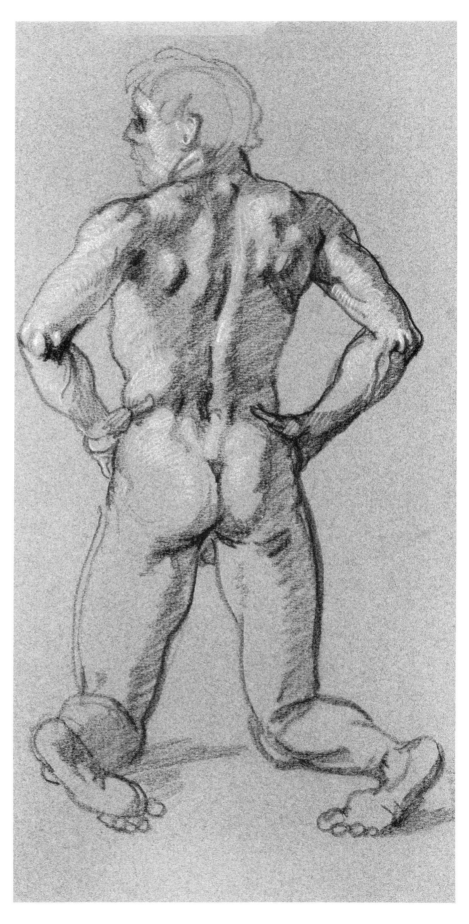

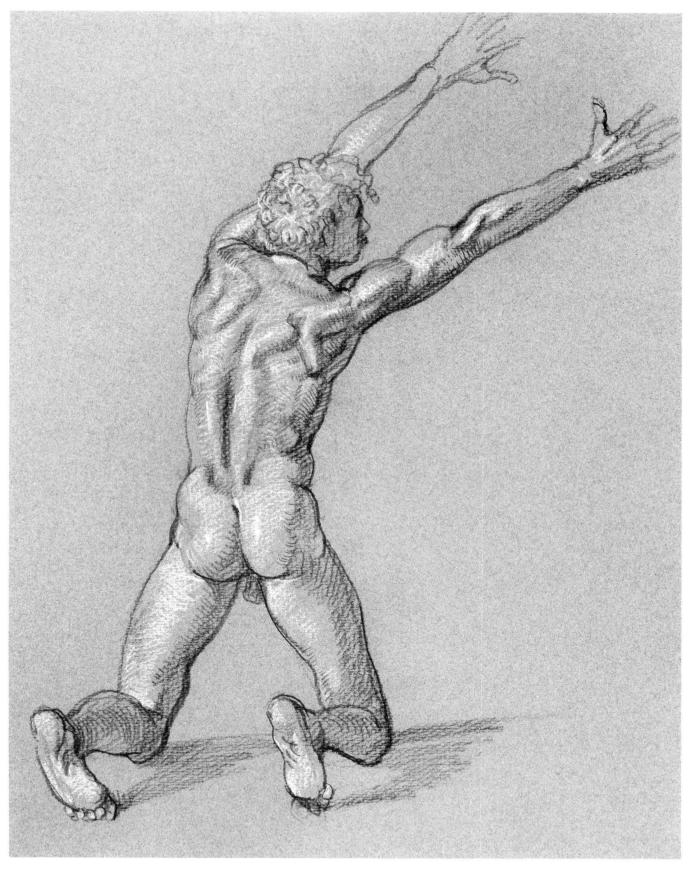

When the arms are raised, the bottom of the shoulder blades follow. The muscles from the shoulder blades attach out into the arms. They help to pull the arm back into place and rotate it.

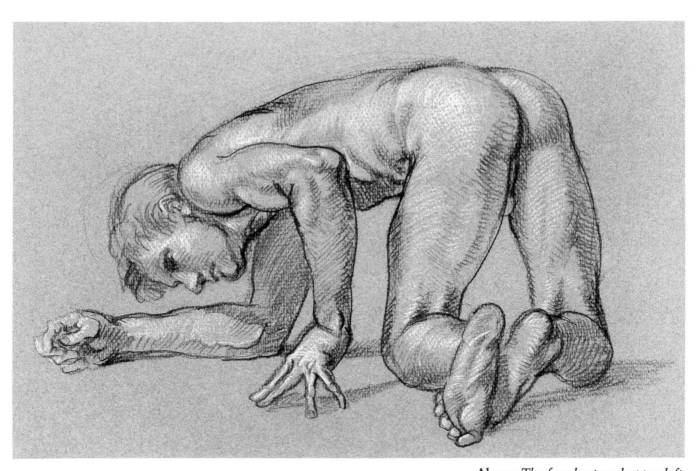

Above: *The foreshortened upper left arm is defined by overlapping lines, and a dark accent around the elbow helps bring the elbow forward. The male's hips are narrow.*

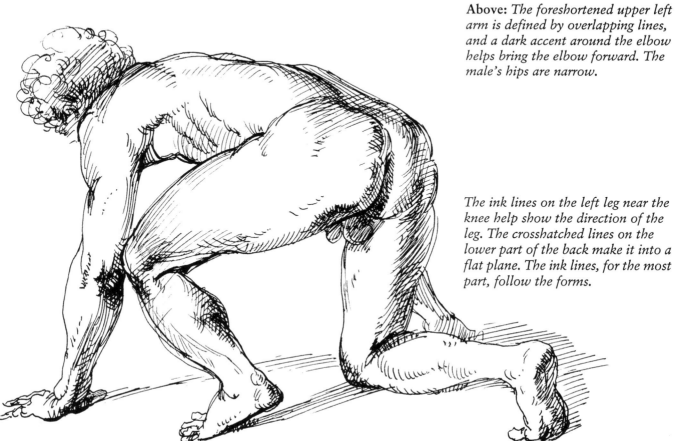

The ink lines on the left leg near the knee help show the direction of the leg. The crosshatched lines on the lower part of the back make it into a flat plane. The ink lines, for the most part, follow the forms.

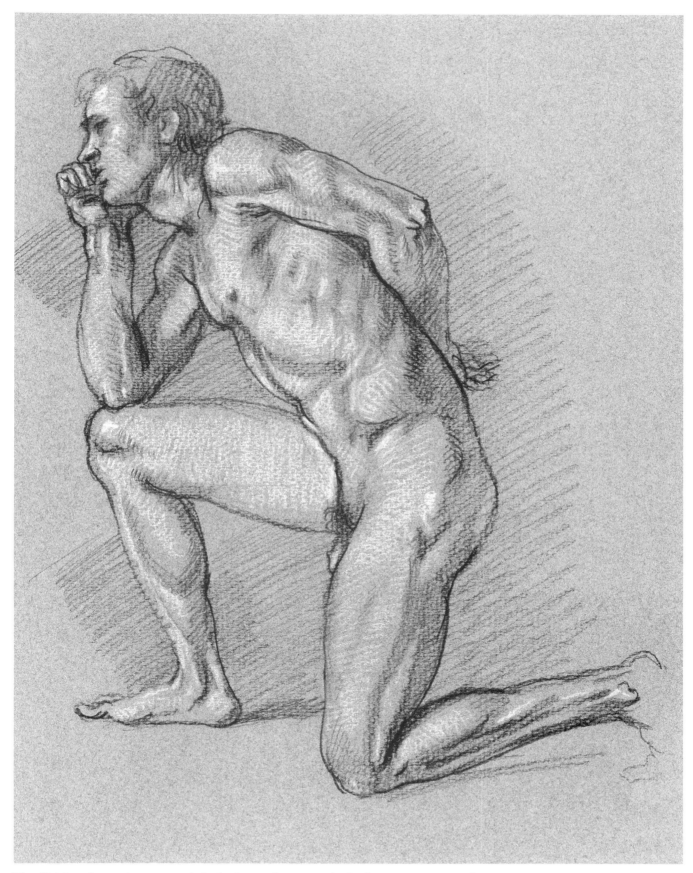

The division down the center of the body can be seen. The hipbone projects out from the pelvis and is the fourth head measurement. The two large muscles on the inside of the calf are clearly defined.

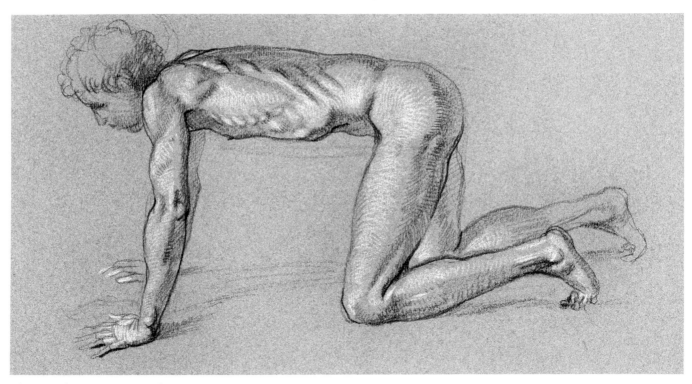

Above: *The serratus muscles appear from beneath the latissimus dorsi muscle (see diagram) and attach to the ribs. The two floating ribs can be seen at the bottom of the rib cage.*

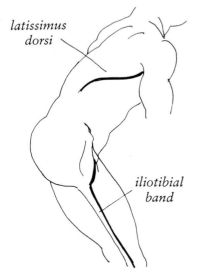

latissimus
dorsi

iliotibial
band

A large muscle, called the latissimus dorsi, rises from the spine and pelvis and extends out into the arm, forming the back wall of the armpit (see diagram). A band (the iliotibial band) runs down the outside of the leg from the gluteus muscles in the buttocks to the head of the large bone below the knee.

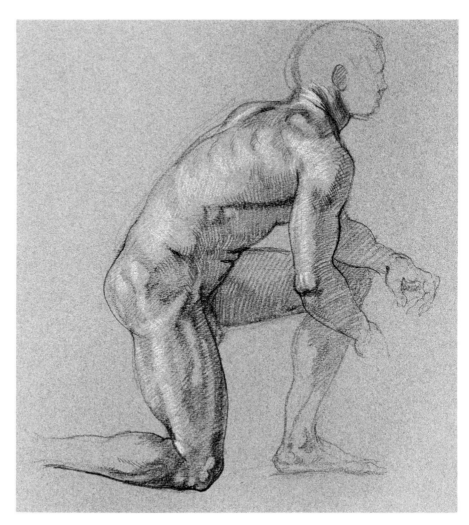

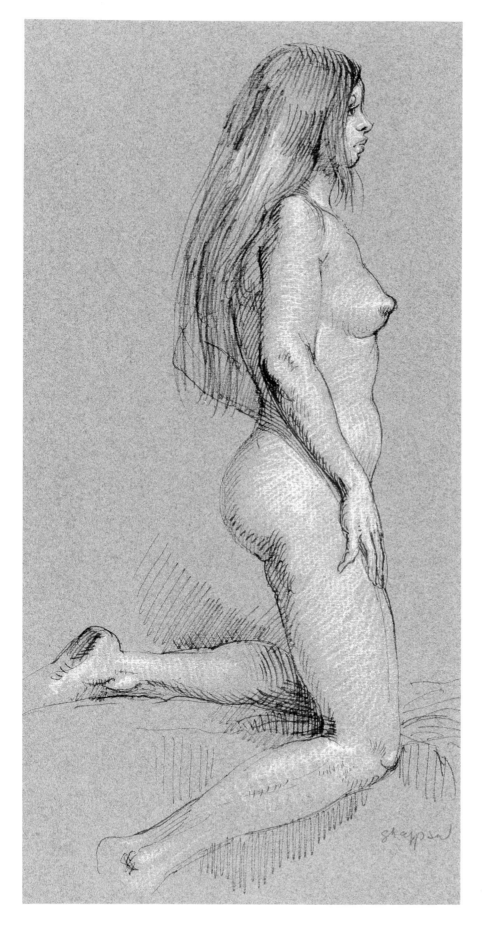

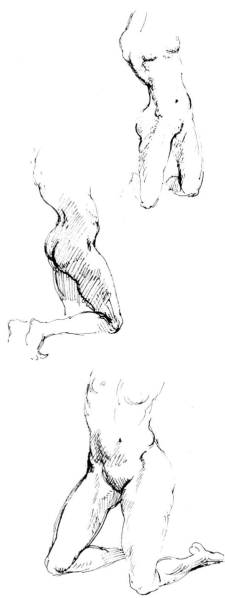

Above: *The same pose seen from three different angles. The raised arms throw the rib cage forward. The pelvis thrusts forward, holding the belly.*

Left: *The bone on the little finger side of the hand is prominent next to the flat space of wrist. The nipple of the breast points upward.*

THE CROUCHING FIGURE
VII

E xcept for a few flat-footed positions, the crouching figure gives the feeling of expectant action or of action just completed. The weight distribution is temporary. Foreshortened arms and legs become a drawing challenge.

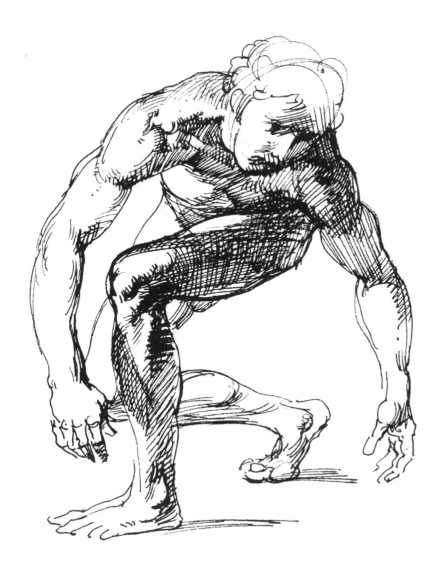

The dark lines around the knee bring it forward. From the arm, cast shadows fall on the forward leg and help push the arm forward. The round kneecap and the triangular form of the bone beneath it are well defined.

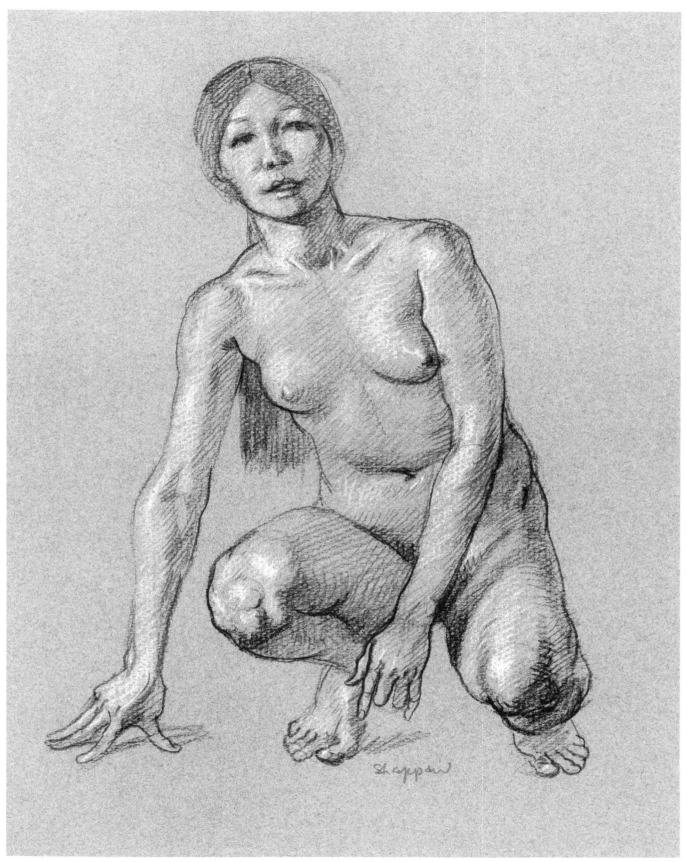

The forms of the upper left arm and breast push against each other, as do the forms of the upper and lower parts of the right leg, changing the normal contours. The dark outline and cast shadow bring the left hand forward.

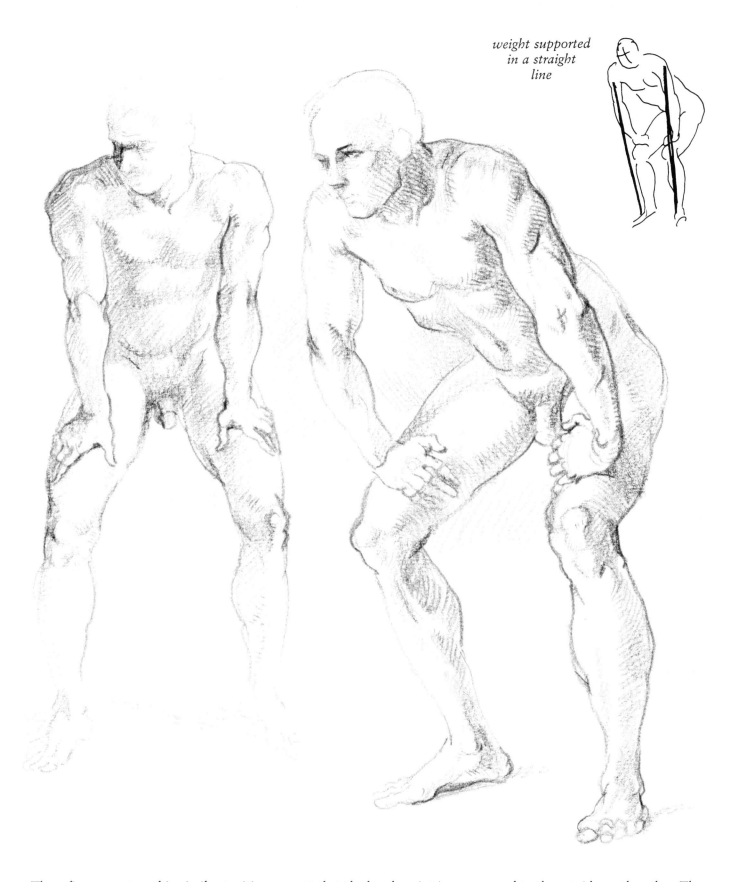

weight supported in a straight line

These figures are posed in similar positions except that the hands point in on one and to the outside on the other. The torso weight is carried in a straight line from the lower leg through the length of the arm to the shoulder (see diagram). The locked arm flexes the triceps.

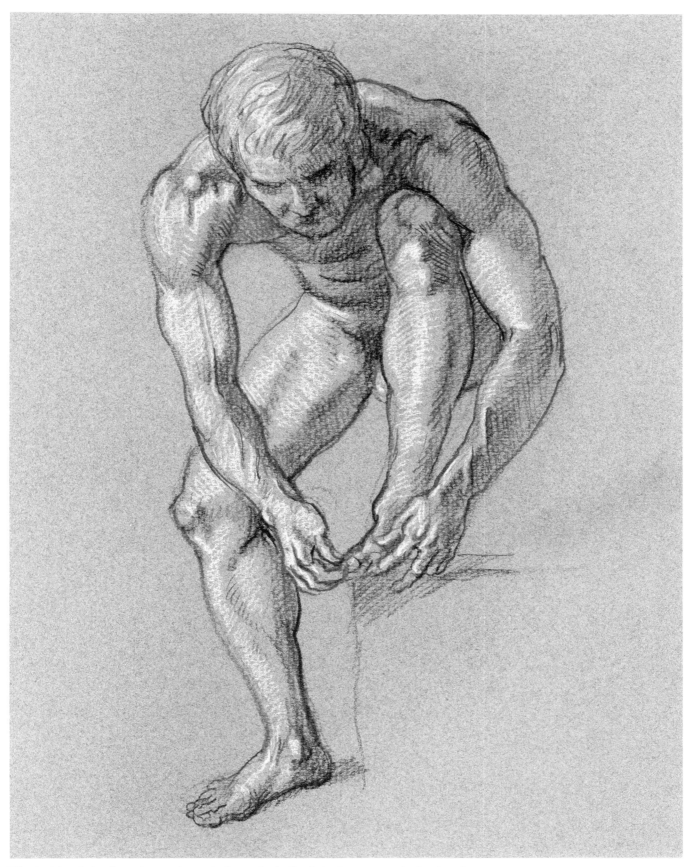

The inside of the foot shows the arch from the ball of the big toe to the heel. A large vein runs down the upper arm between the biceps and triceps and breaks up into smaller tributaries on the inside of the forearm.

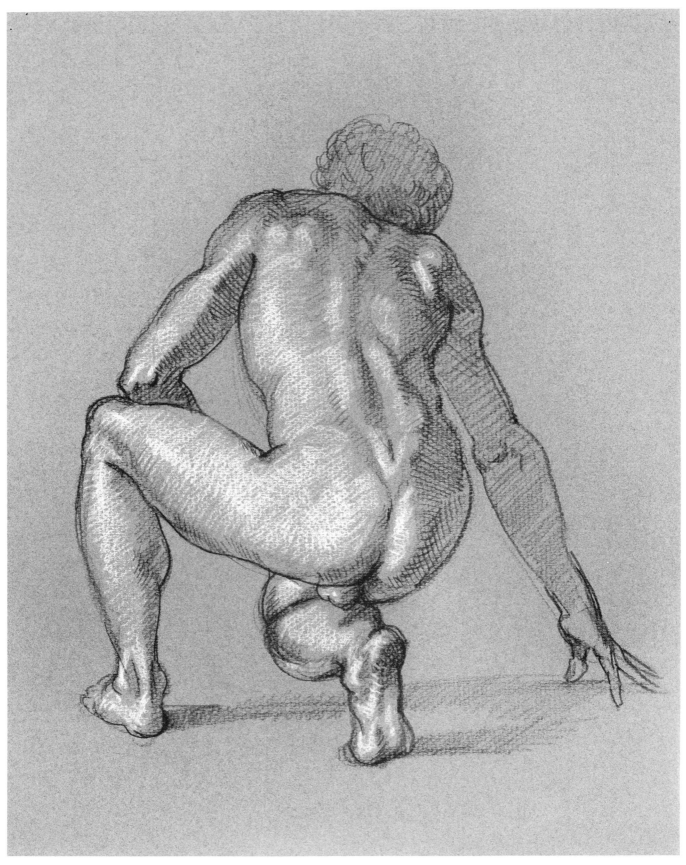

The backbone twists and the shoulders slant with it. The different shapes of the bent and straight elbow can be seen. The flat V shape of the bottom of the spine is evident between the buttock muscles.

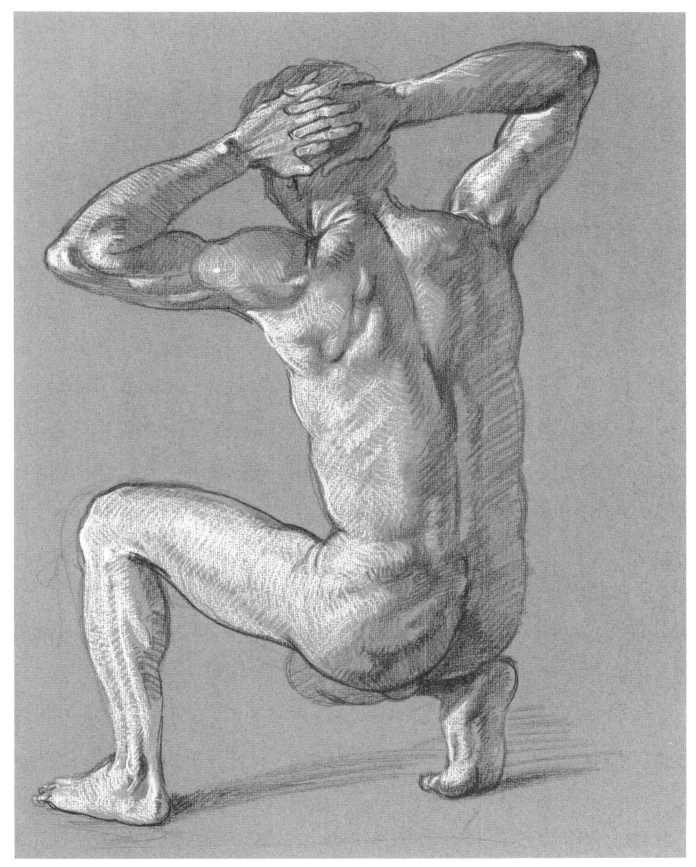

The large latissimus dorsi muscle enters the arm and forms the back wall of the armpit. In the upper left arm, light hits two of the three tricep heads. The separations of the fibers of the gluteus muscle or buttocks can also be seen.

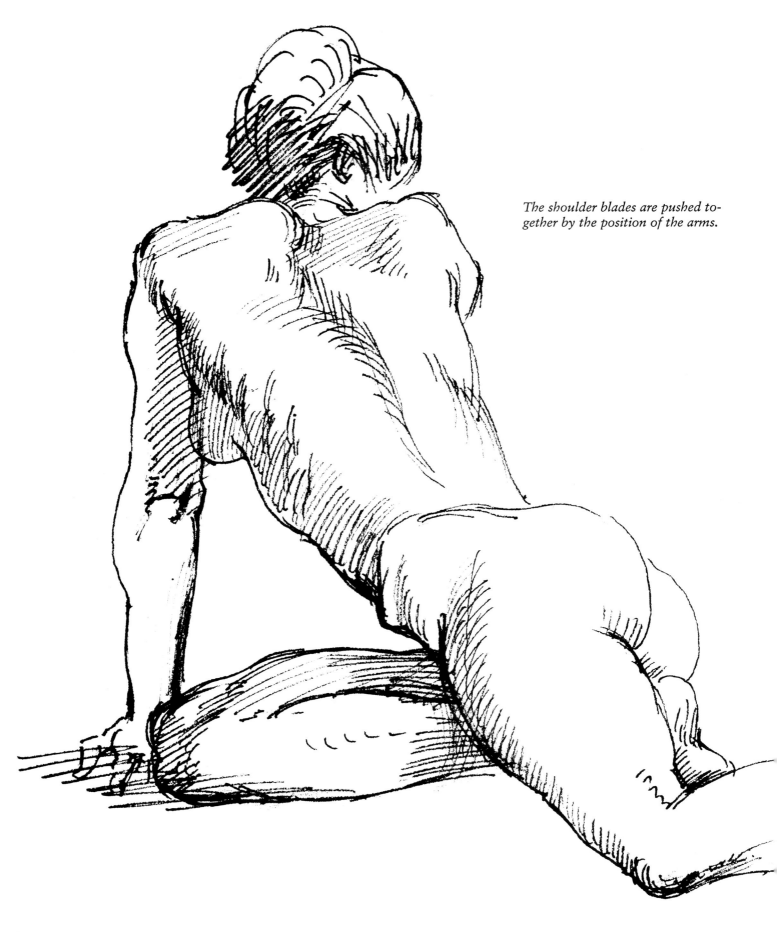

The shoulder blades are pushed together by the position of the arms.

80

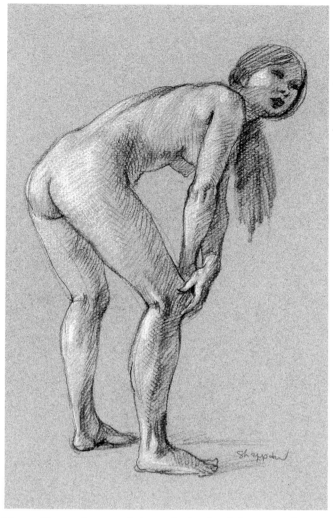

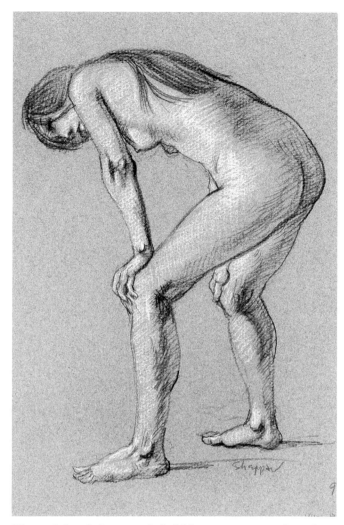

The calf muscles attach into the back of the upper leg above the knee. The model is balanced on both bent legs.

The weight of the torso is held by a continuous line that starts from the shoulders and descends through the arms and into the lower part of the leg (see diagram below). The inside anklebone is closer to the front of the foot than the outside anklebone.

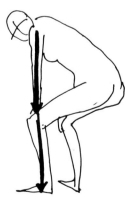

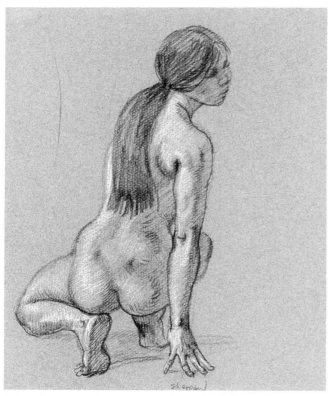

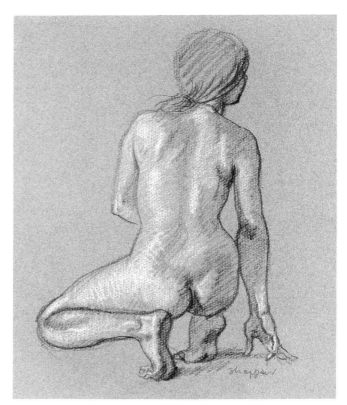

The triangular flat shape at the end of the backbone is evident. The outside of the foot is flat and the inside is arched.

Weight is held by the toes, and one hand is used for balance. The shoulders' rib cage and the shoulder blades turn together.

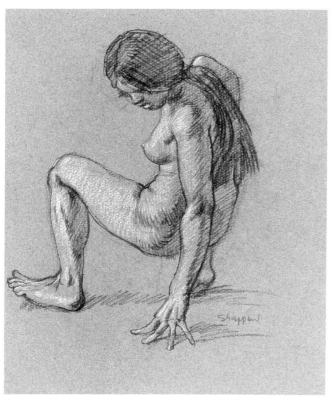

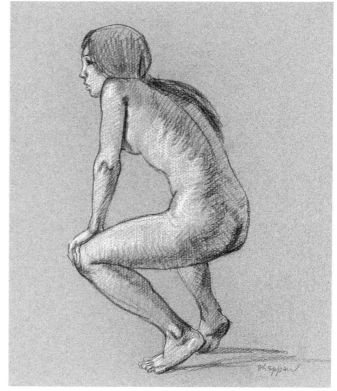

Weight is mostly on the extended fingers. The muscles of the arm and the calf harden as they help support the weight.

The model is completely balanced on her toes. The back arches forward and the downward slant of the ribs can be seen. The arms are locked against the legs.

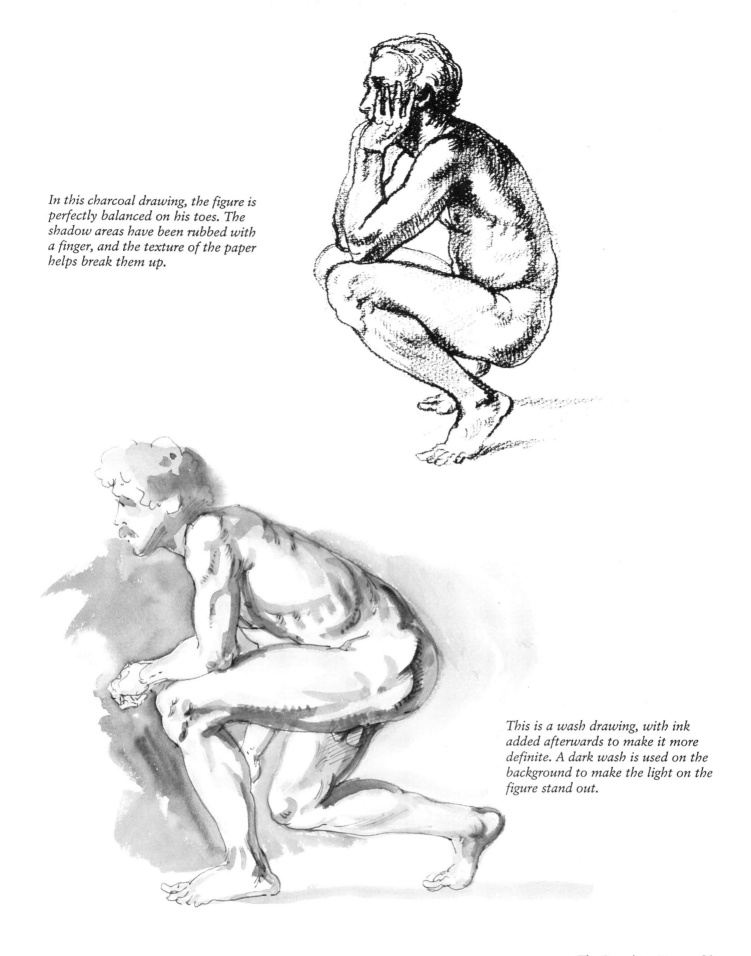

In this charcoal drawing, the figure is perfectly balanced on his toes. The shadow areas have been rubbed with a finger, and the texture of the paper helps break them up.

This is a wash drawing, with ink added afterwards to make it more definite. A dark wash is used on the background to make the light on the figure stand out.

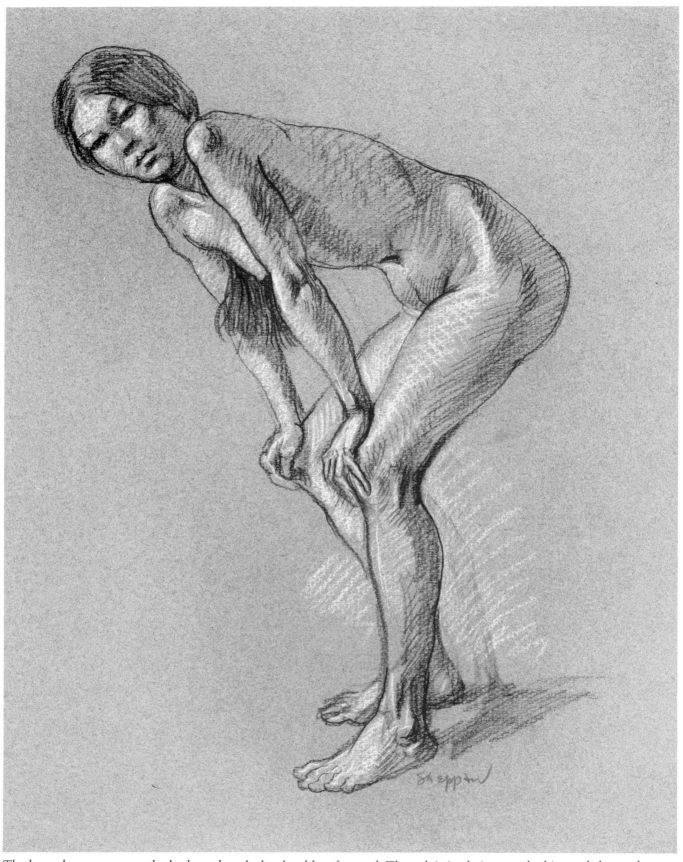

The braced arms support the body and push the shoulders forward. The pelvis is obvious at the hip, and the tendons at the knee and ankle are tensed.

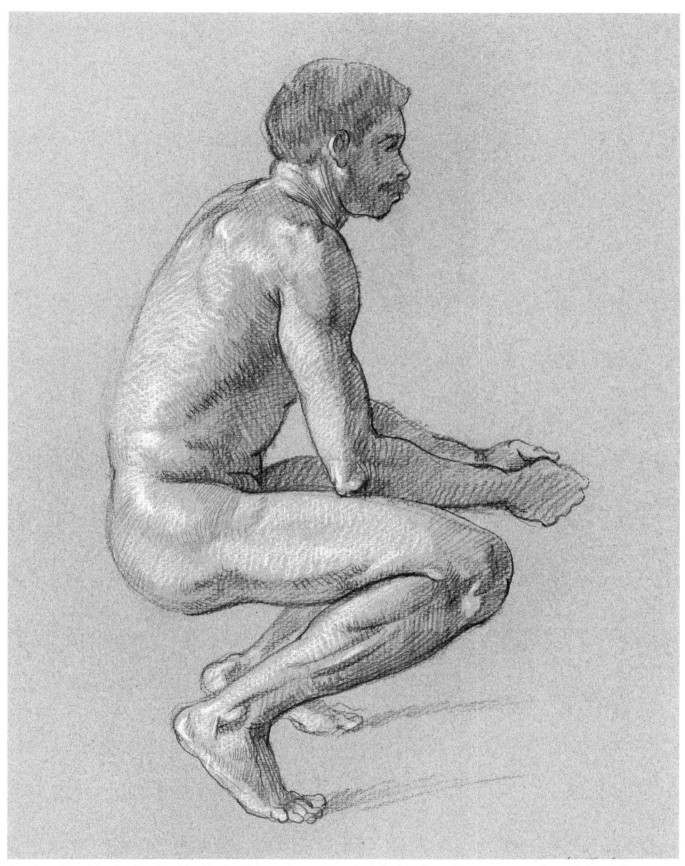

On the relaxed back, the shoulder blade sticks out prominently. The hands and arms counter the weight of the torso, balancing the model as he supports himself on his toes.

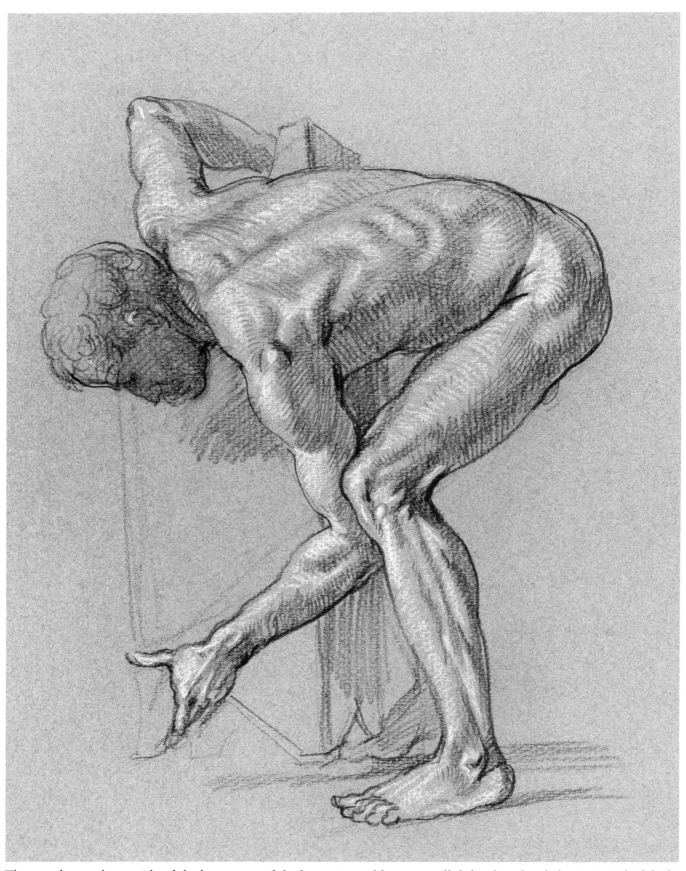

The muscles on the outside of the lower part of the leg strain and become well defined as they help support the lifted load. The biceps in front of the upper arm swell as they help lift the object.

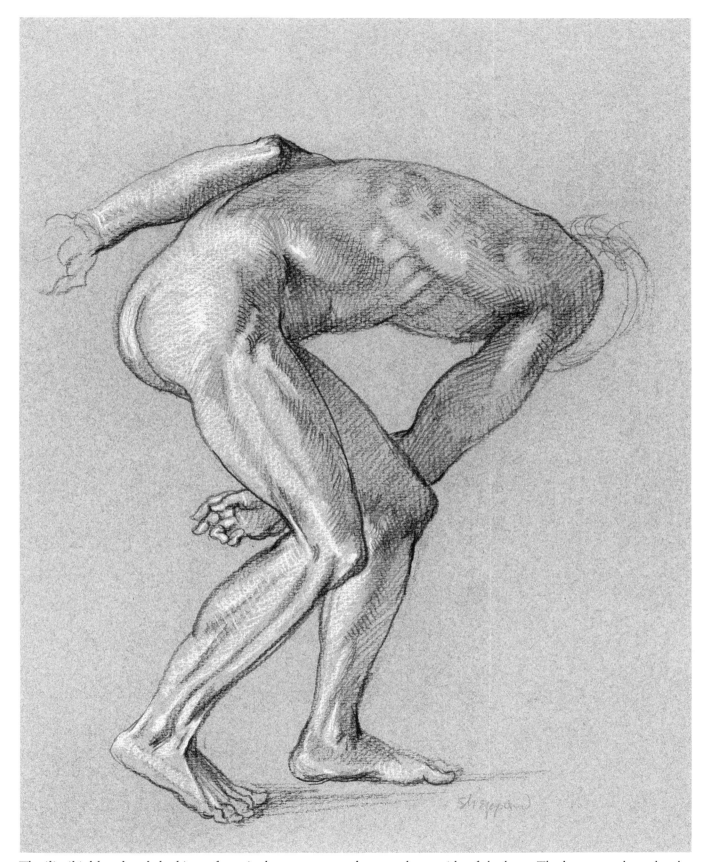

The iliotibial band and the biceps femoris show as two tendons on the outside of the knee. The large muscle under the iliotibial band is called the vastus lateralis. The tendon of the biceps femoris attaches to the fibula or outside bone of the lower part of the leg. The fibula can always be seen at the ankle and outside of the knee.

THE RECLINING FIGURE
VIII

F oreshortened limbs and difficult angles make the reclining figure seem more difficult to draw. Proportion becomes the biggest problem. The upright figure is more familiar to the eye and therefore easier to conceive than the reclining one. The eight-head measurement is hard to use if there is any foreshortening. Probably the easiest way to measure is to divide the length of the figure in half and then in quarters, finding a new point of reference for measurement.

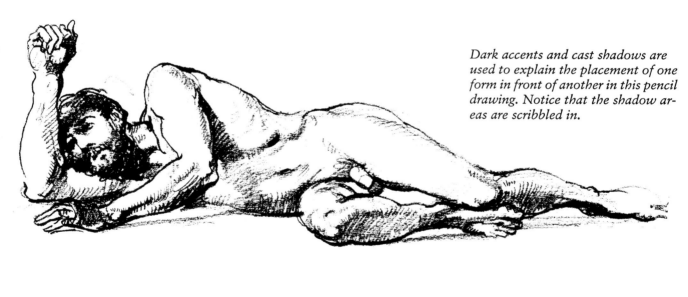

Dark accents and cast shadows are used to explain the placement of one form in front of another in this pencil drawing. Notice that the shadow areas are scribbled in.

The knee is well defined and brought forward by the cast shadow. A series of overlapping forms makes the fore-shortened thigh work. The weight of the model is suggested by the lines of the pillow.

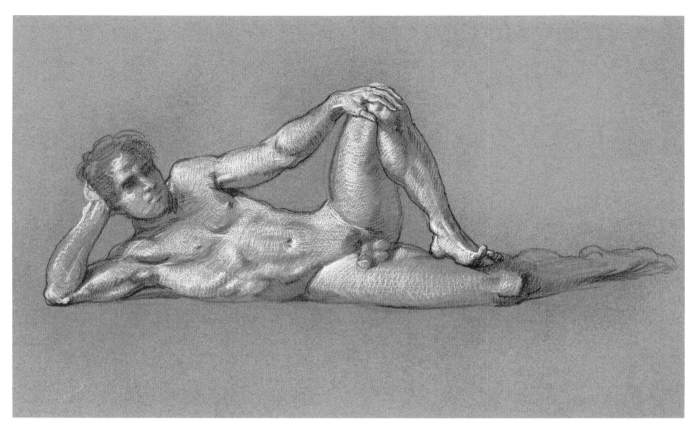

Above: *On this dark paper, most of the drawing is done with light instead of shadow. The light lines are still applied in the direction of the form that they depict. The extensor of the big toe can be seen lifting the toe.*

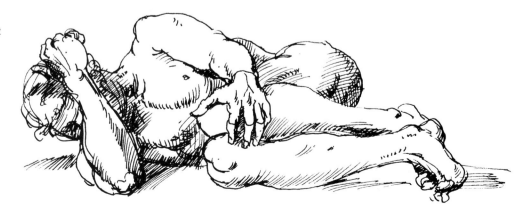

Both these poses are similar. The dark shadow on the thighs contrasts with and pushes out the light, lower part of the leg. The square shape of the wrist forms a bridge between hand and arm.

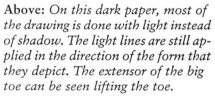

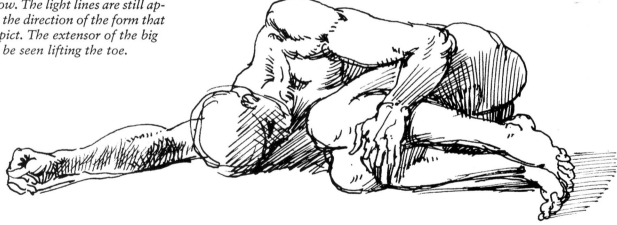

89

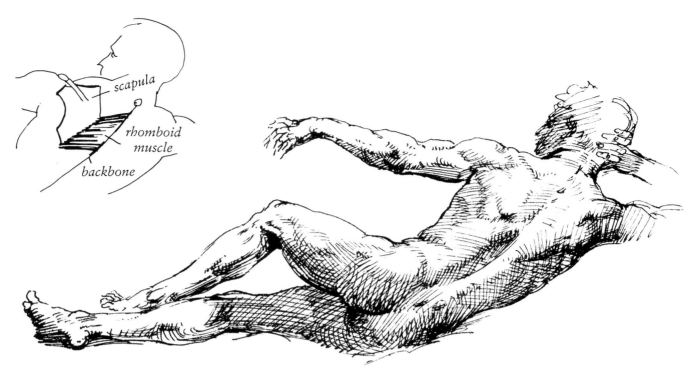

A flat plane is formed by the rhomboid muscle, which runs along the bottom edge of the shoulder blade to the backbone (see diagram). The shape of the shoulder blade can be seen on the back.

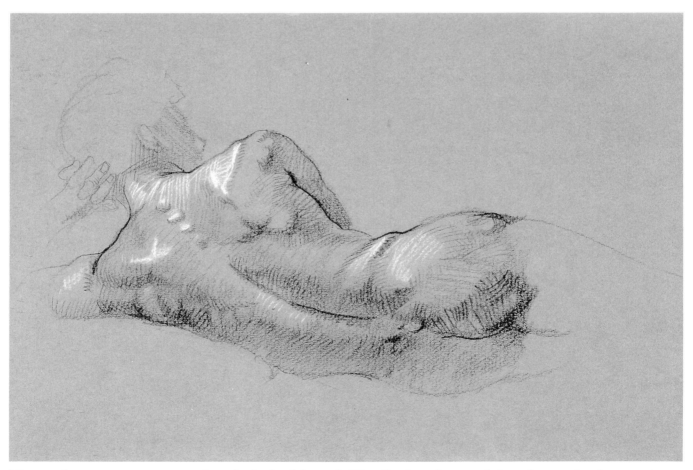

The vertebrae are very pronounced on the back of the neck. The ribs slant down and show from under the trapezius muscle in the center of the back, and the two ends of the pelvic crest can be seen.

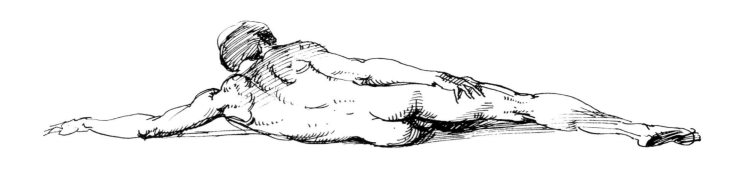

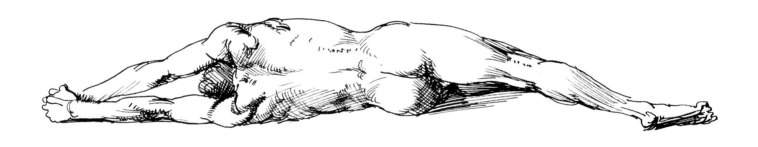

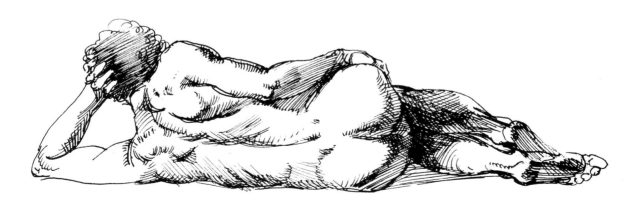

As the position of the arms changes, the shapes of the muscles of the upper back change. The leg positions change the muscles in the lower back to a lesser degree.

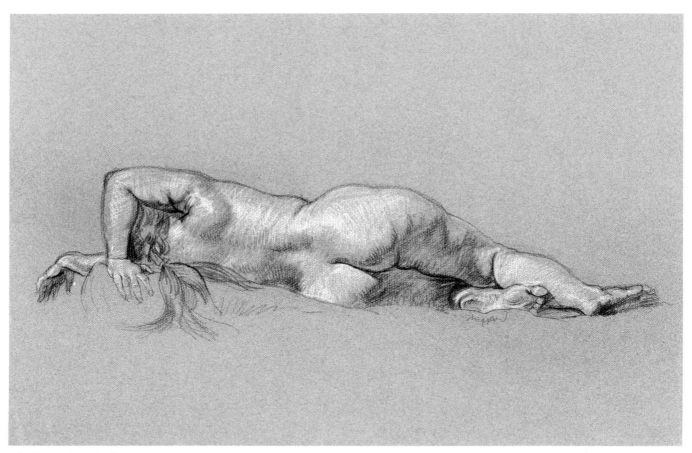

The basic female form stays the same even when the model is heavy. Dimples appear on the backs of the thighs from fat. The middle finger is always the longest finger.

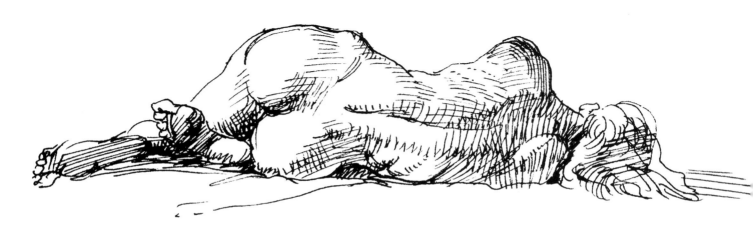

The pelvis is pushed up. Only the sole of the right foot is seen, but it suggests the complete position of the hidden leg.

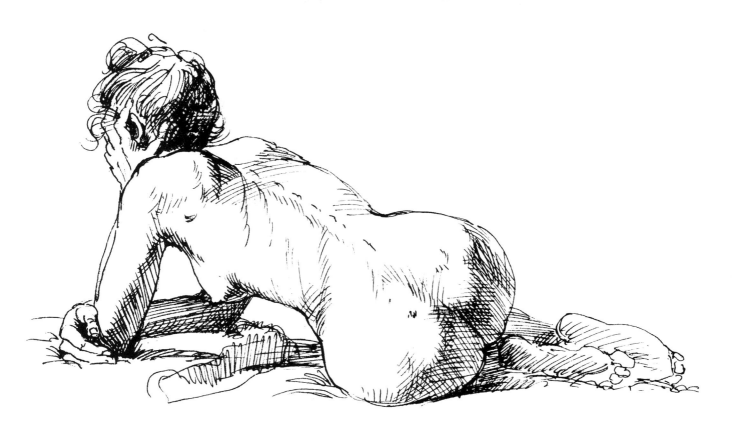

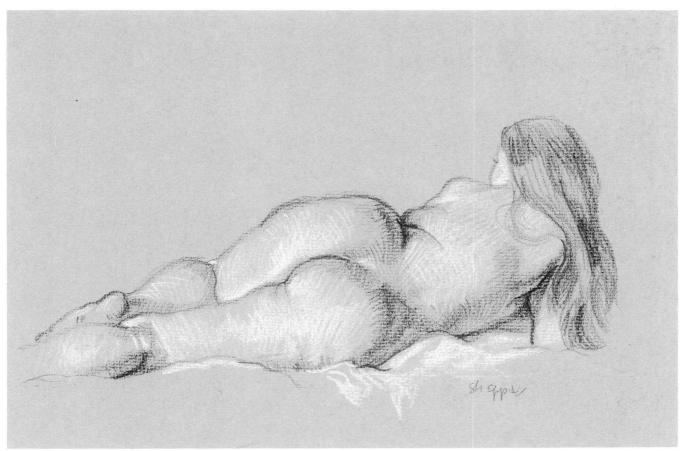

Top of page: *The ribs and backbone are prominent. The raised knees force the buttocks into a smoother round shape.*

Above: *The highlight on the back thigh pushes the front thigh forward. In this position the buttock fold disappears.*

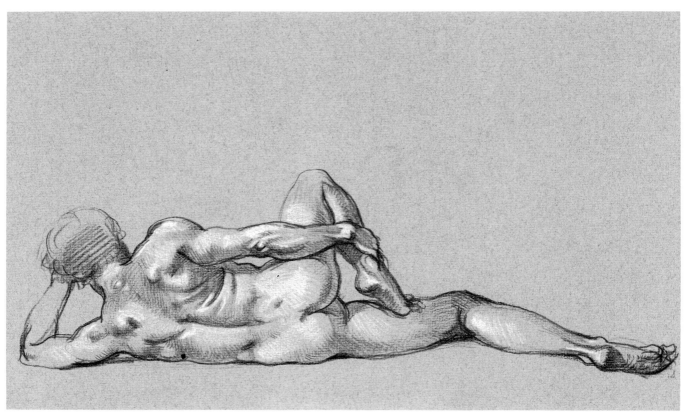

Creases are formed on the torso when the leg is raised and the arm is pulled back. The hips and shoulders are at opposite angles.

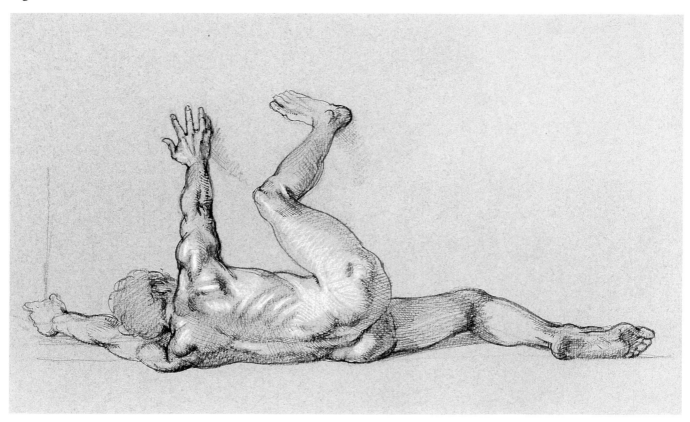

This technique—charcoal drawing reworked with ink—was used by many Old Masters, and really helps explain each form.

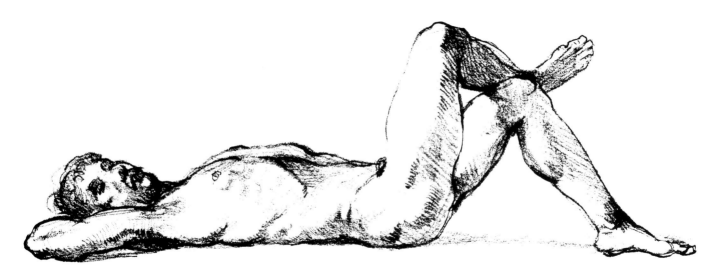

Both sides of the rib cage seem to project upward, making the cavity deep. The stomach flattens out.

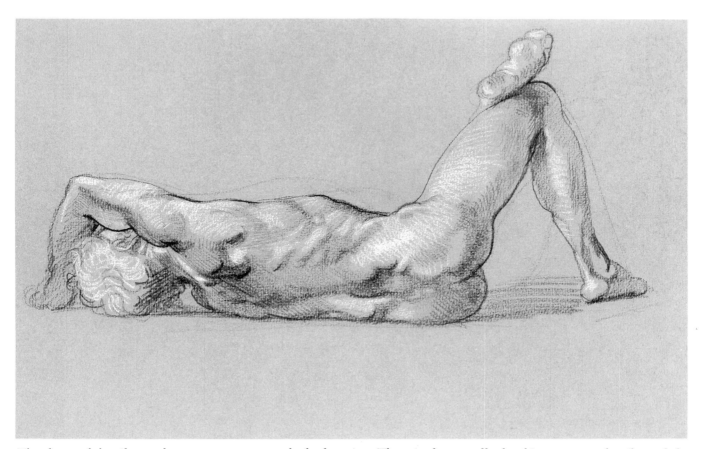

The shape of the rib cage becomes apparent as the body twists. The raised arm pulls the skin taut over the ribs and the muscles.

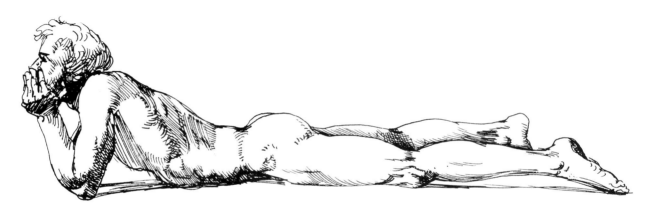

Above: *The abdomen and thighs flatten out against the supporting surface from the weight of the body. The buttocks are flexed because of the extended toes.*

Above, opposite page: *The torso is raised and supported by the arms, making the backbone arch.*

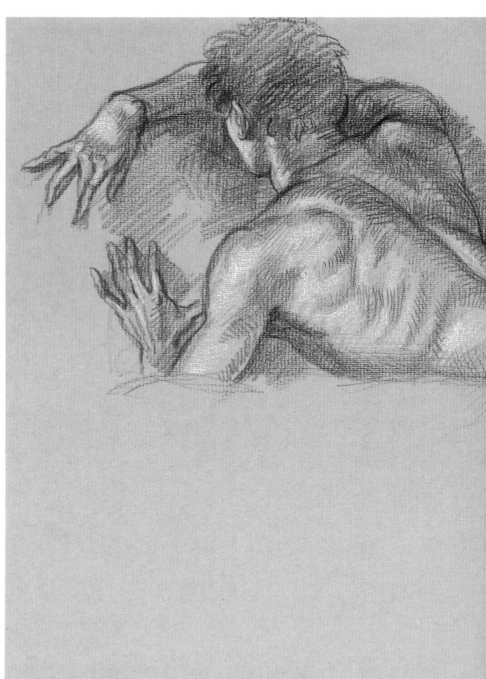

A diffused edge is kept between the figure and the soft supporting surface. The back is arched and the left buttock tightens as it helps extend the left leg. The left knee is locked, supporting the lower part of the left leg.

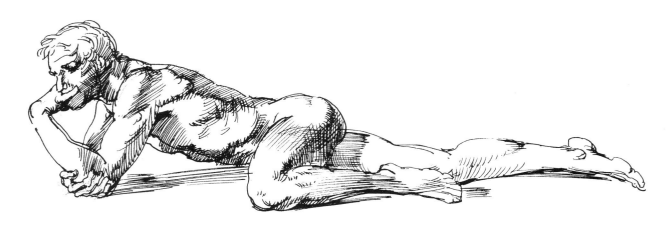

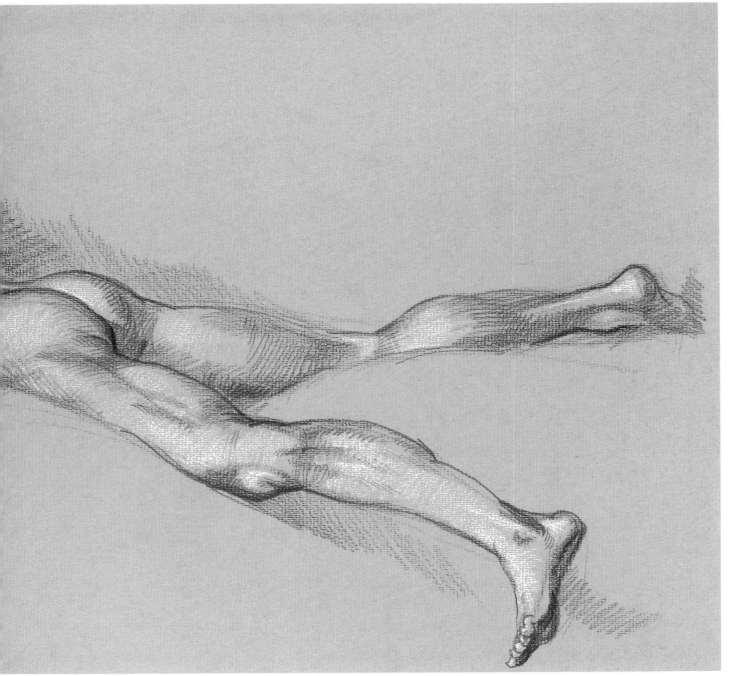

THE
FORESHORTENED
FIGURE
IX

I n the foreshortened figure we have to think of forms as sections, one in front of another. Most measuring devices do not work. It is important not to work too close to the subject, as a near object appears larger than normal, creating a distortion. Intersecting and overlapping lines become important and cast shadows help push one form in front of another. Finding the parts of the body that align with each other is necessary in drawing the foreshortened figure.

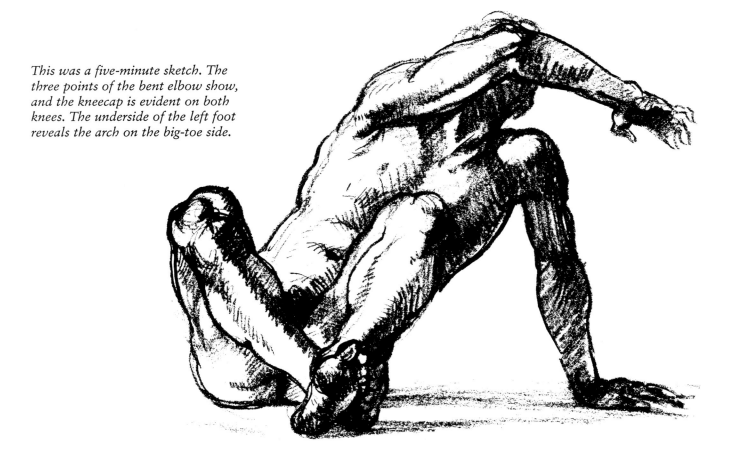

This was a five-minute sketch. The three points of the bent elbow show, and the kneecap is evident on both knees. The underside of the left foot reveals the arch on the big-toe side.

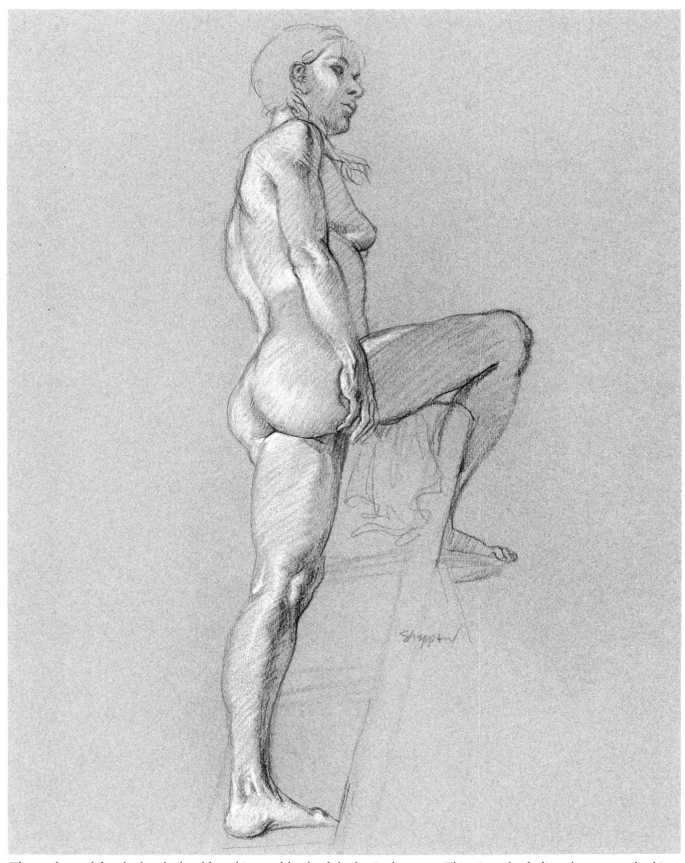

The angle used for the head, shoulders, hips and back of the leg is the same. This gives the feeling that we are looking up and that the right side is higher than the left.

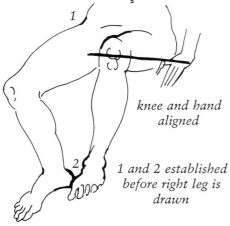

knee and hand
aligned

1 and 2 established
before right leg is
drawn

Drawing the underside of the chin
and nose puts the head in perspective.
Once the left knee is established, it is
easy to align the hand and pubic area.
The right leg is drawn after the two
extreme points—the two feet to-
gether and the hips—are determined
(see diagram above).

Opposite page: The viewpoint is ex-
plained by drawing the underside of
the thigh and chin. The foot is slightly
enlarged because it is closer. (This can
easily be overdone and create an un-
desirable photographic "fish-eye
lens" look.)

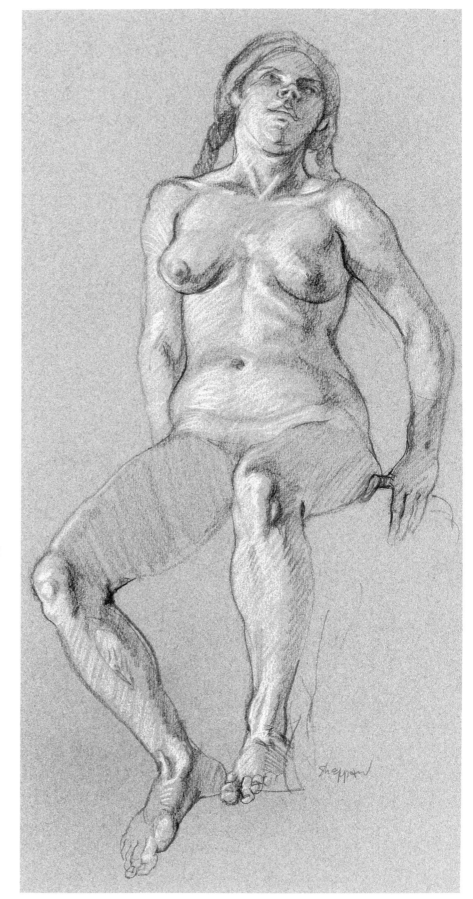

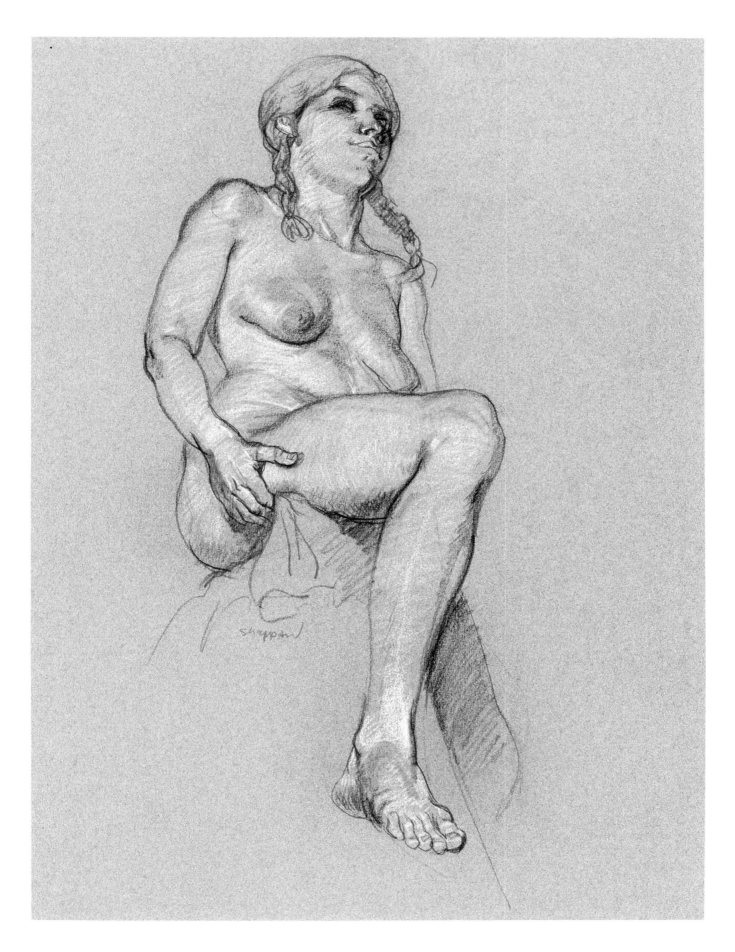

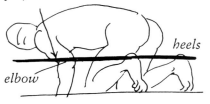

projected horizontal line

heels

elbow

Any kind of head measurement is impossible in the foreshortened figure. Finding forms that intersect horizontal or vertical lines can help. For instance, the elbow and both heels are on the same line.

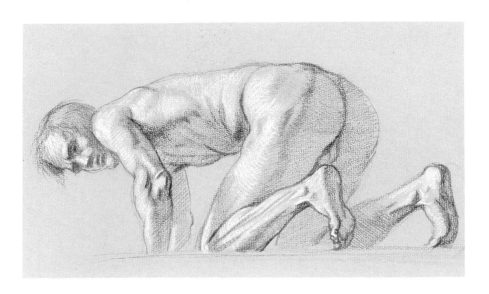

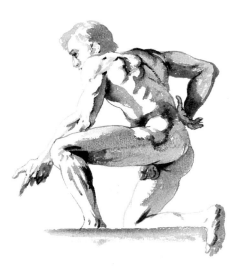

This is a wash drawing done with a brush. The figure was first drawn in with light tones. The dark accents were added after the initial wash was dry.

The cavity of the rib cage is defined by a dark shadow. The rib attachments on the chest are evident, and the collarbones angle back. On the right knee, the outline of the top inside bone is round and high; the outside bone of the left knee is sharper. The kneecap sits between these two bones.

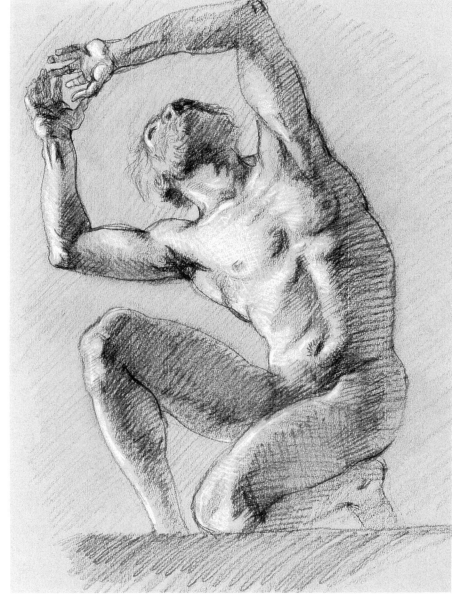

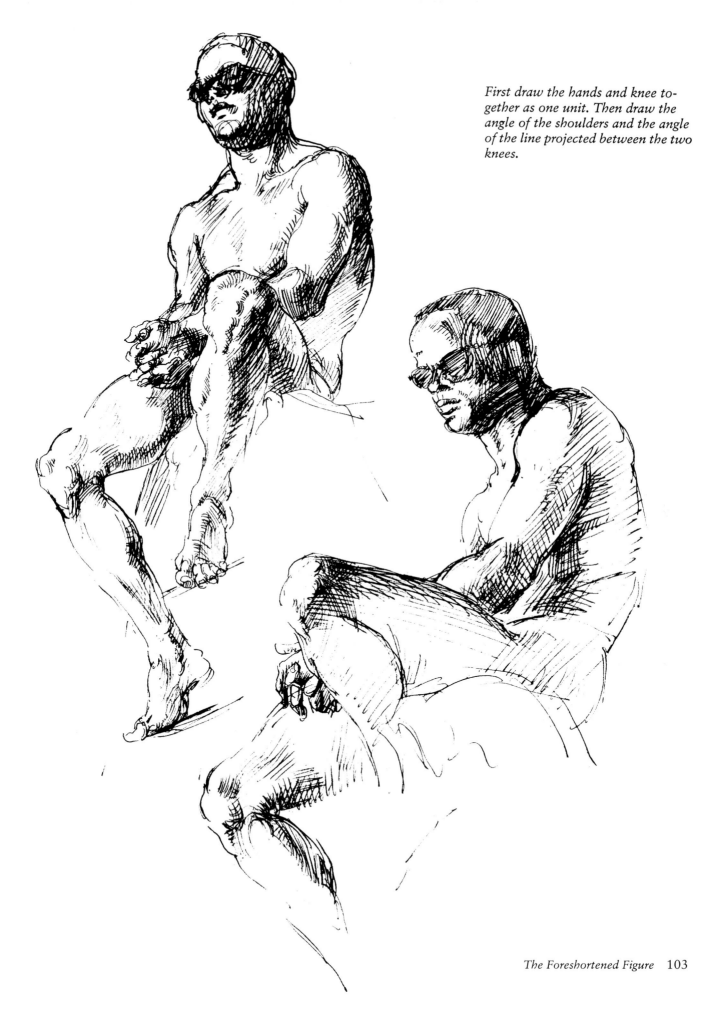

First draw the hands and knee to-
gether as one unit. Then draw the
angle of the shoulders and the angle
of the line projected between the two
knees.

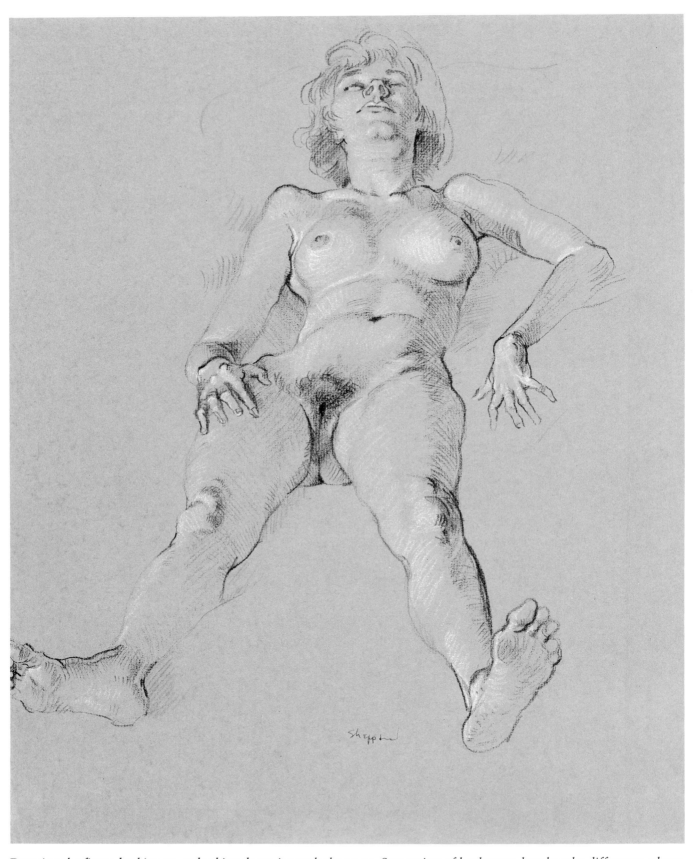

Drawing the figure looking up or looking down is much the same. Suggestion of background makes the difference, along with the pull of gravity on the soft, fleshy parts of the figure. Here the breasts lie aside and the stomach flattens, making the figure lie down.

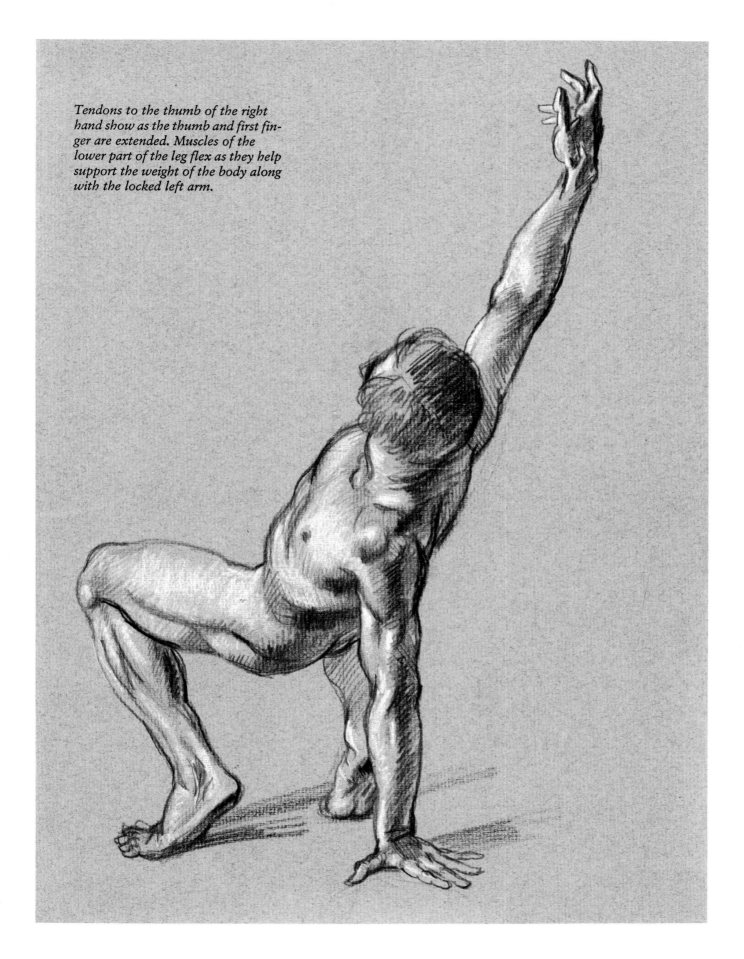

Tendons to the thumb of the right hand show as the thumb and first finger are extended. Muscles of the lower part of the leg flex as they help support the weight of the body along with the locked left arm.

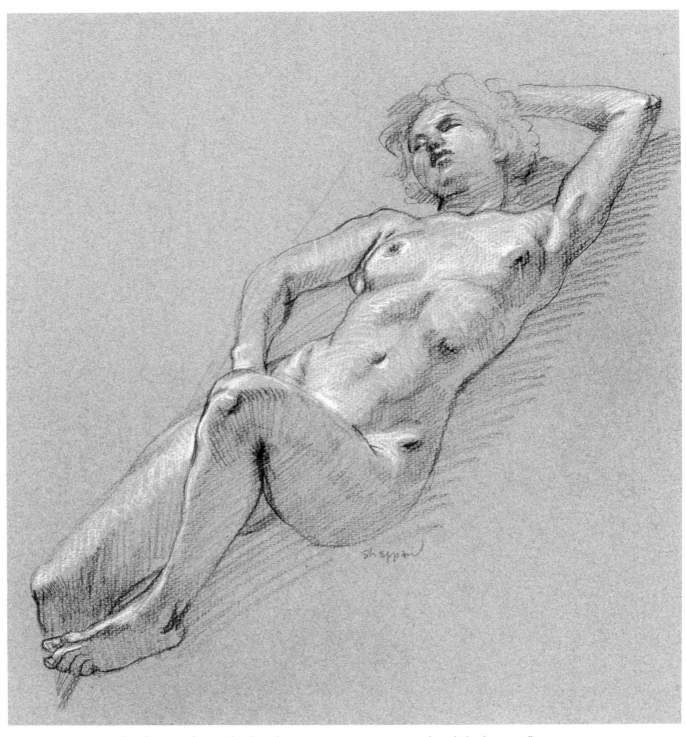

The knee is accented to bring it forward. The rib cage cavity is pronounced and the breasts flatten out.

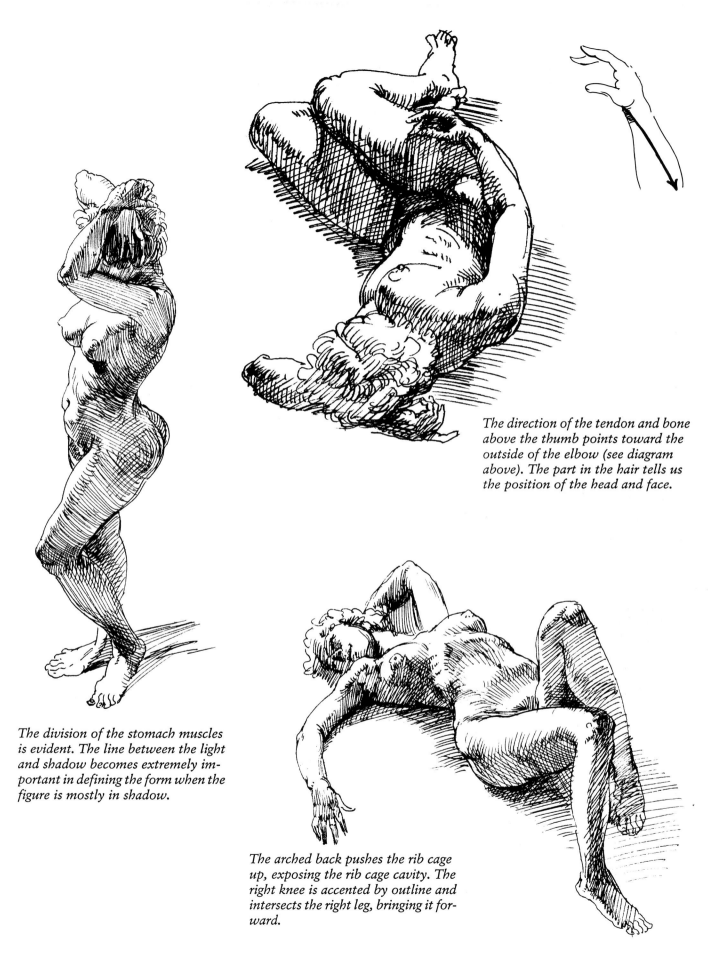

The direction of the tendon and bone above the thumb points toward the outside of the elbow (see diagram above). The part in the hair tells us the position of the head and face.

The division of the stomach muscles is evident. The line between the light and shadow becomes extremely important in defining the form when the figure is mostly in shadow.

The arched back pushes the rib cage up, exposing the rib cage cavity. The right knee is accented by outline and intersects the right leg, bringing it forward.

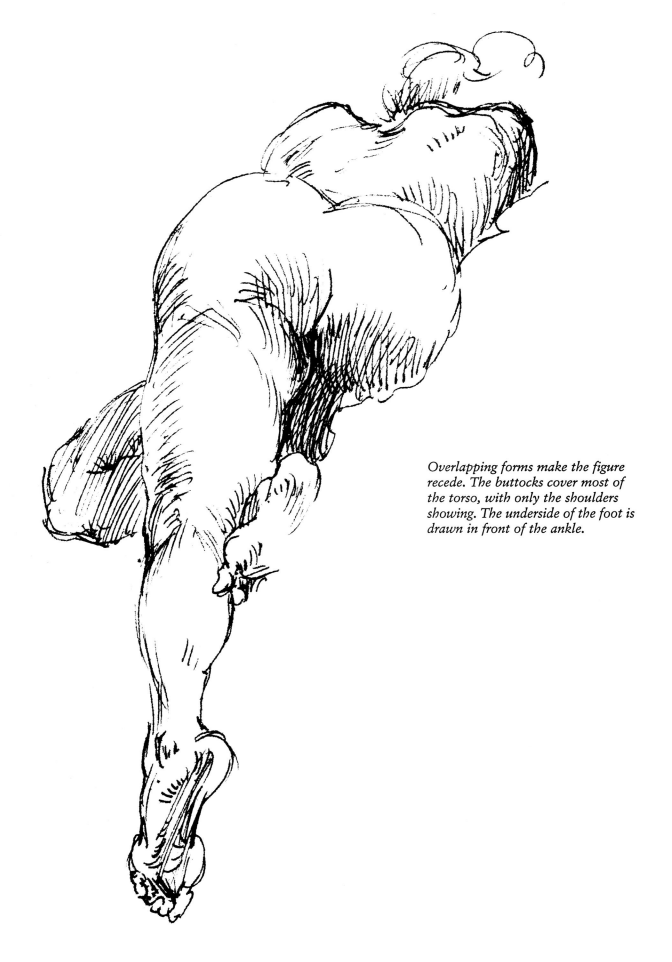

Overlapping forms make the figure recede. The buttocks cover most of the torso, with only the shoulders showing. The underside of the foot is drawn in front of the ankle.

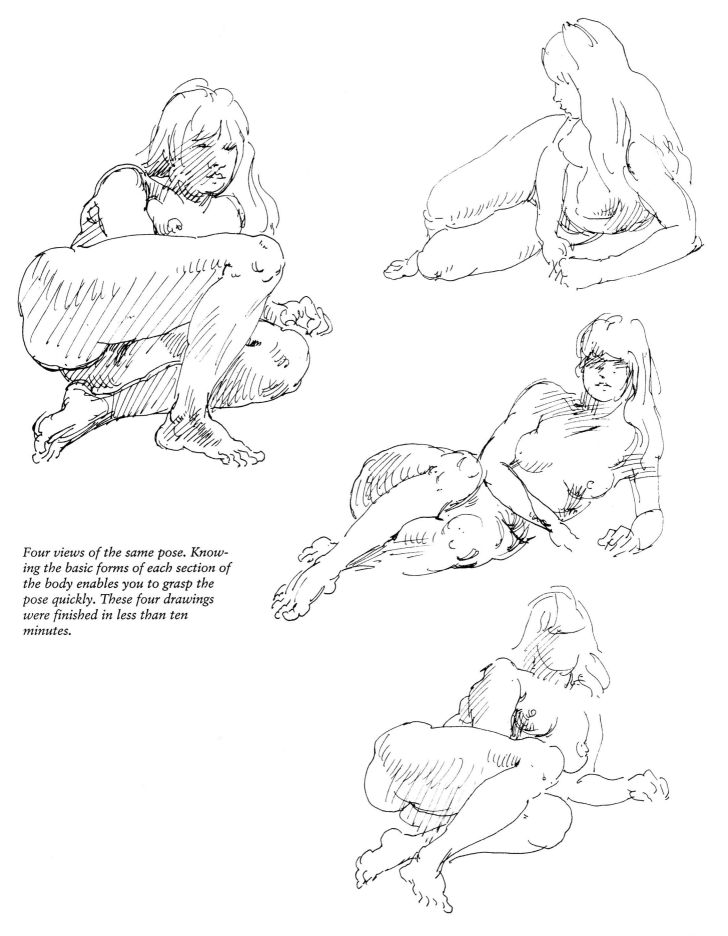

Four views of the same pose. Knowing the basic forms of each section of the body enables you to grasp the pose quickly. These four drawings were finished in less than ten minutes.

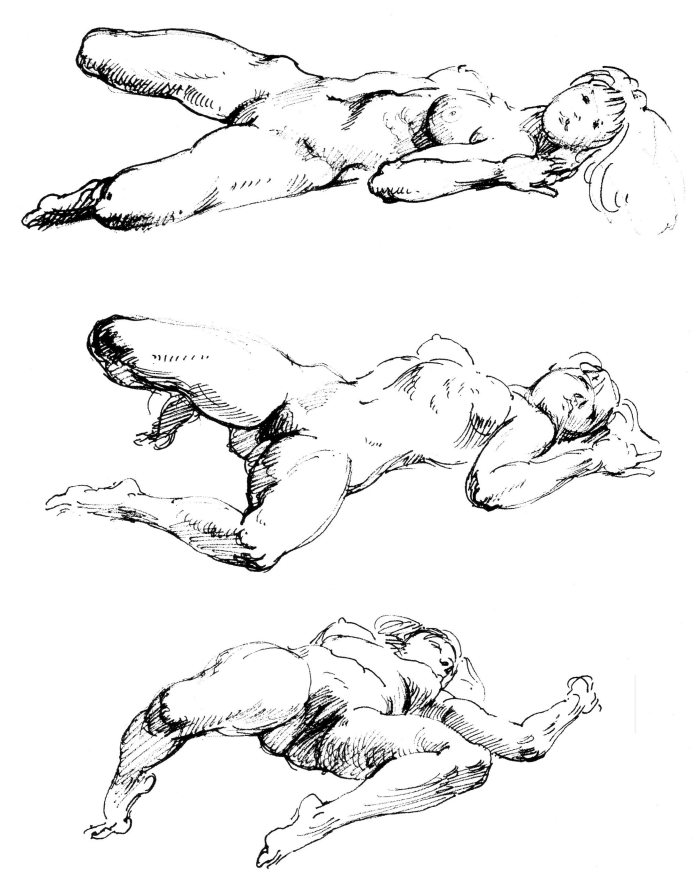

Three views of the same pose. The rib cage is pushed up by the arched backbone. The weight is on the right foot and shoulders.

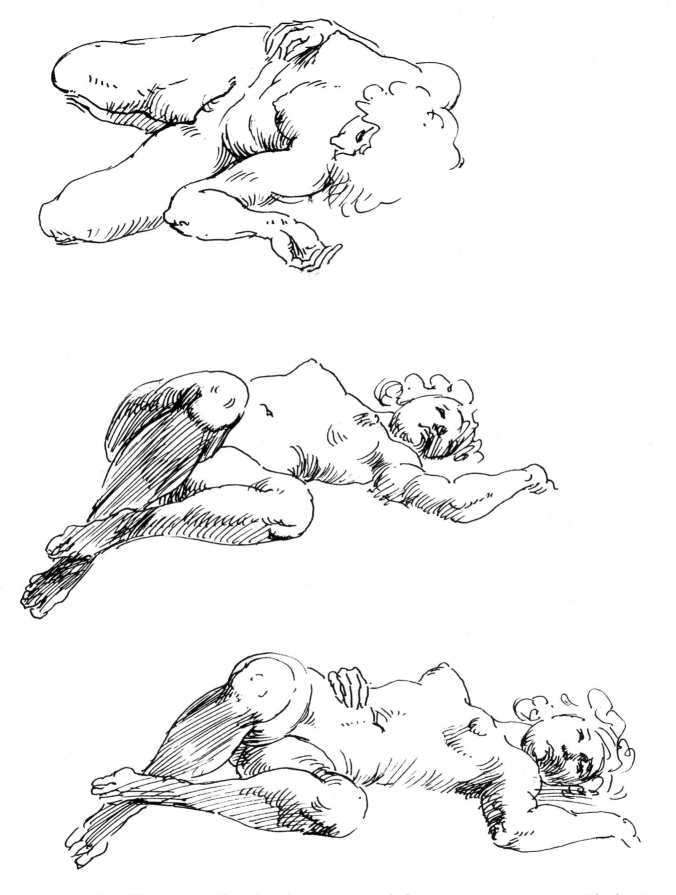

The same pose in three different views. These three drawings were made during one twenty-minute pose. The direction of the shadow lines helps explain the form.

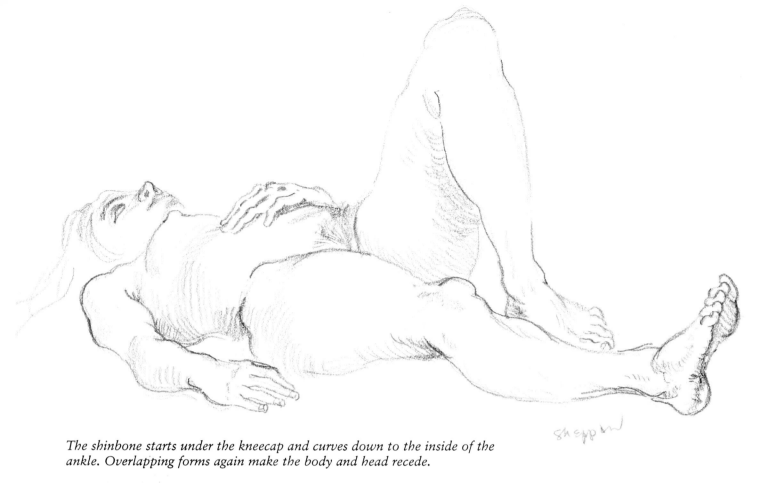

The shinbone starts under the kneecap and curves down to the inside of the ankle. Overlapping forms again make the body and head recede.

The muscle in the back of the calf attaches above the back of the knee. The front of the shinbone has a slight curve.

112

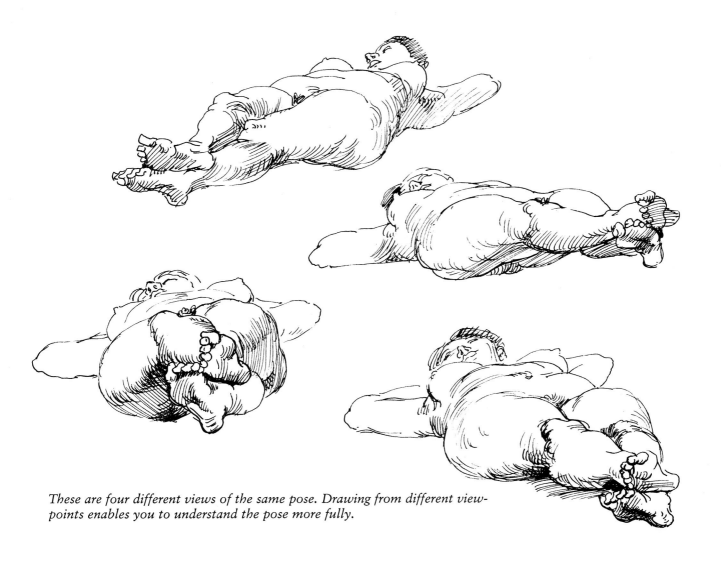

These are four different views of the same pose. Drawing from different view-
points enables you to understand the pose more fully.

A top view of the rib cage reveals its shape in the foreshortened torso. The chest
muscles attach into the arms.

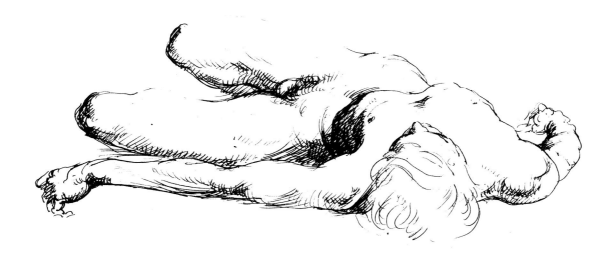

Copies of Old Master drawings.

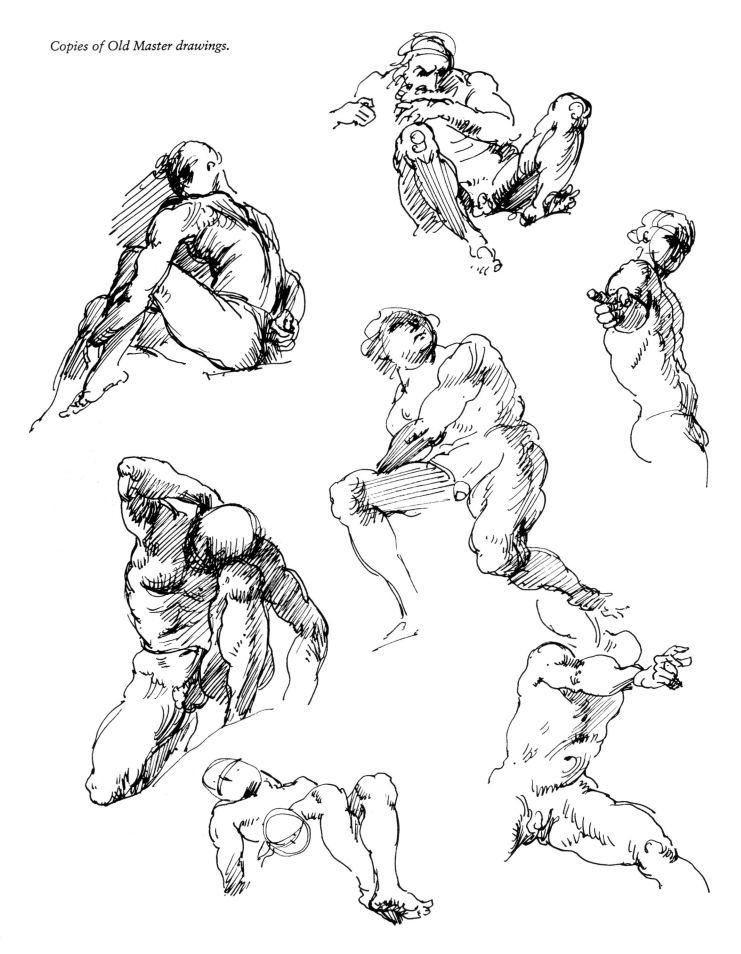

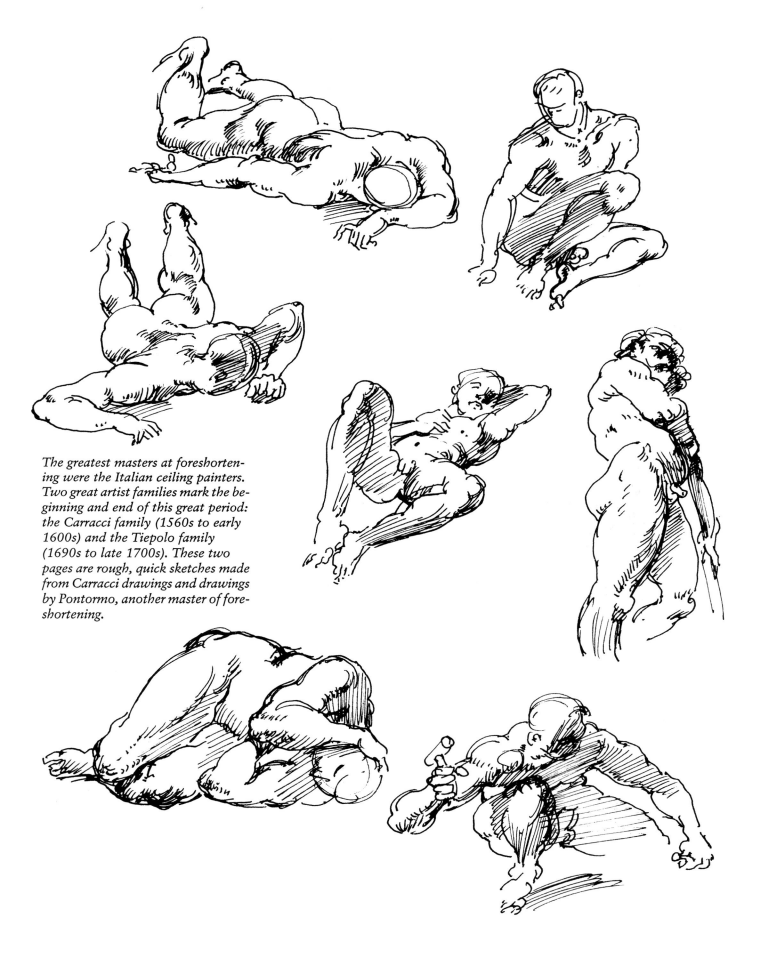

The greatest masters at foreshortening were the Italian ceiling painters. Two great artist families mark the beginning and end of this great period: the Carracci family (1560s to early 1600s) and the Tiepolo family (1690s to late 1700s). These two pages are rough, quick sketches made from Carracci drawings and drawings by Pontormo, another master of foreshortening.

THE FIGURE IN ACTION
X

To make a figure appear to move, it must be drawn freely and not be over-rendered. There are three points of action that are the most expressive: the preparation for the movement, the actual movement and the follow-through. Michelangelo was a master of the first and third points. Rubens was the great master of the actual movement.

The essential thing to get down is the key line of the gesture. It is important to keep the figure off balance to make the action believable.

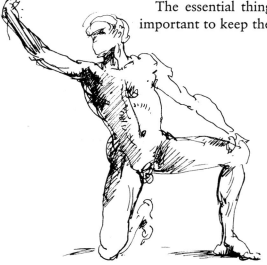

The extremely sketchy left arm still indicates the bulk of each muscle.

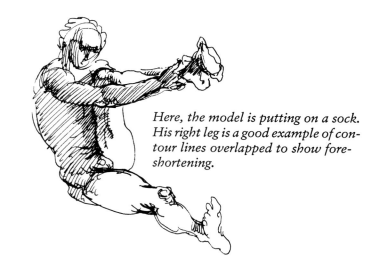

Here, the model is putting on a sock. His right leg is a good example of contour lines overlapped to show foreshortening.

A quick sketch should be done in much the same way you write your signature.

The direction of the ribs helps explain the twisted torso.

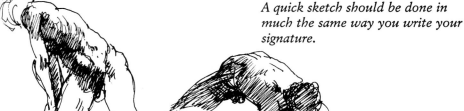

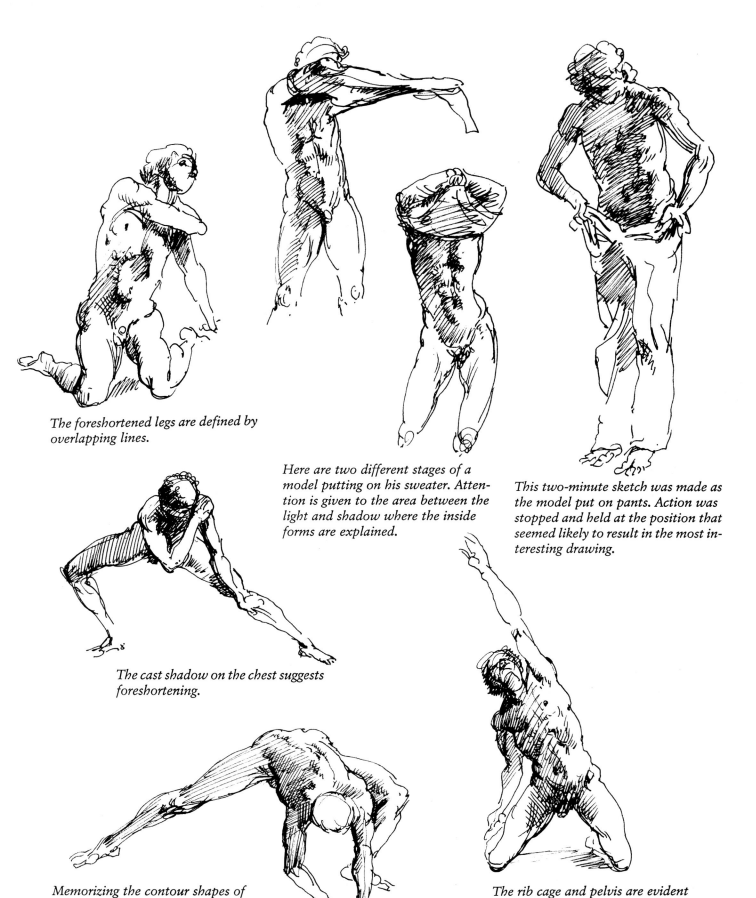

The foreshortened legs are defined by overlapping lines.

Here are two different stages of a model putting on his sweater. Attention is given to the area between the light and shadow where the inside forms are explained.

This two-minute sketch was made as the model put on pants. Action was stopped and held at the position that seemed likely to result in the most interesting drawing.

The cast shadow on the chest suggests foreshortening.

Memorizing the contour shapes of each section of the body helps when drawing a quick pose.

The rib cage and pelvis are evident here. The darker areas come forward; the light areas recede.

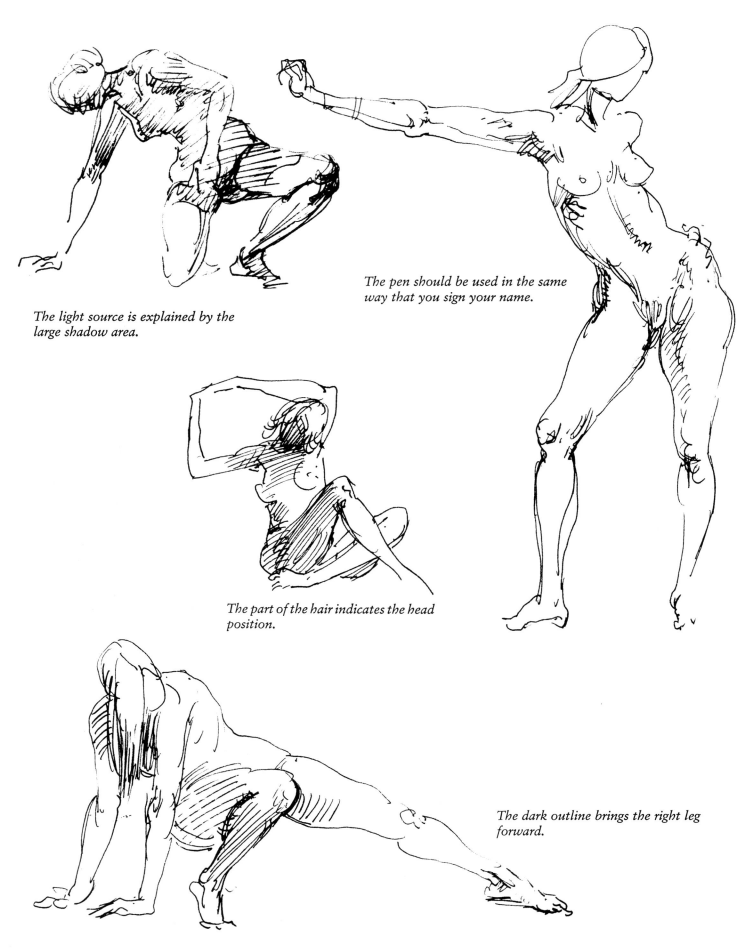

The light source is explained by the large shadow area.

The pen should be used in the same way that you sign your name.

The part of the hair indicates the head position.

The dark outline brings the right leg forward.

118

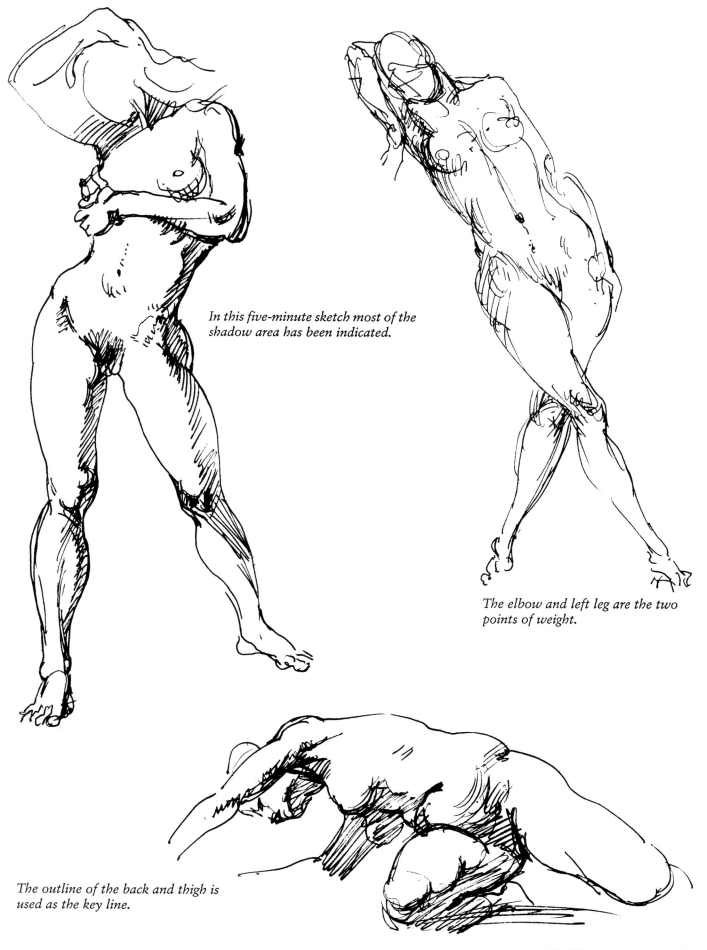

In this five-minute sketch most of the shadow area has been indicated.

The elbow and left leg are the two points of weight.

The outline of the back and thigh is used as the key line.

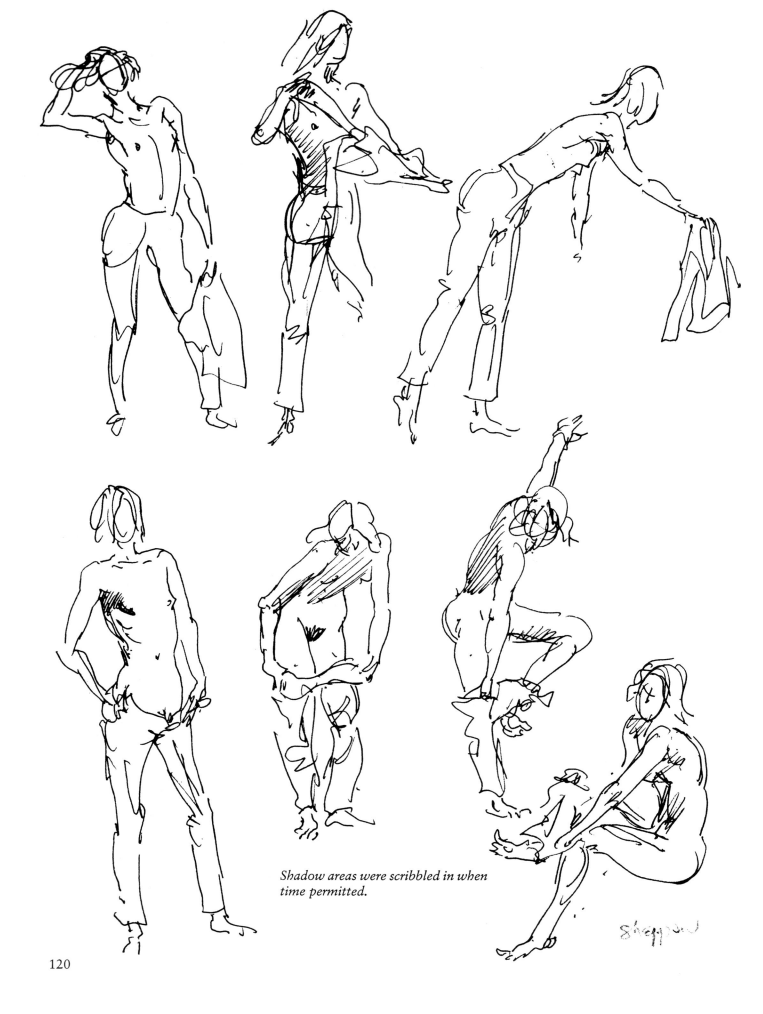

Shadow areas were scribbled in when time permitted.

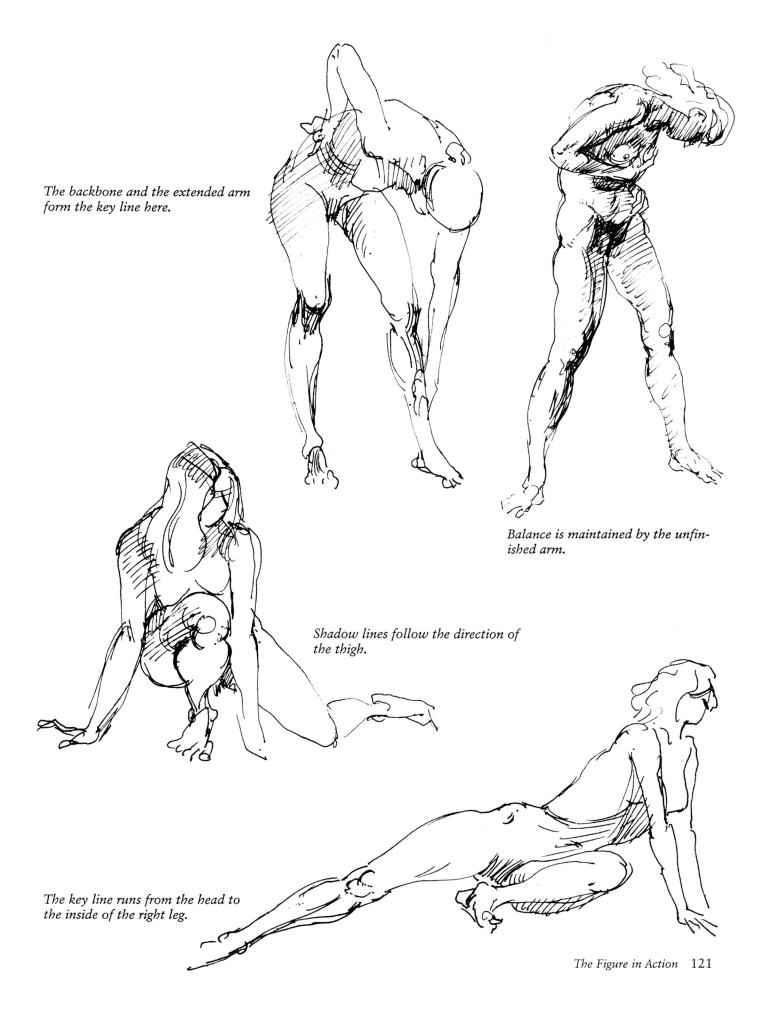

The backbone and the extended arm form the key line here.

Balance is maintained by the unfinished arm.

Shadow lines follow the direction of the thigh.

The key line runs from the head to the inside of the right leg.

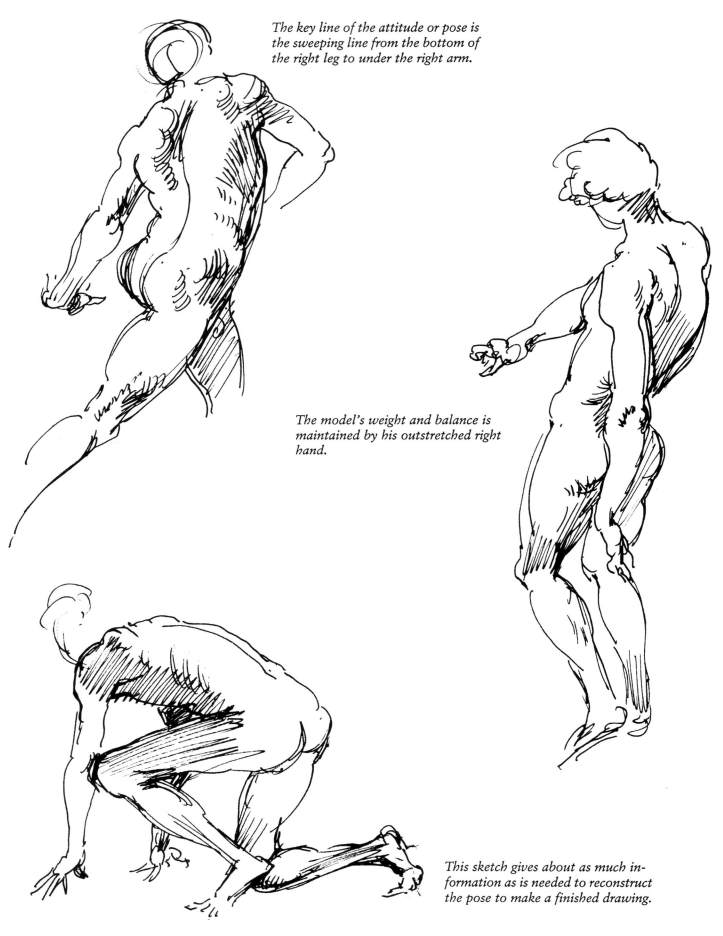

The key line of the attitude or pose is the sweeping line from the bottom of the right leg to under the right arm.

The model's weight and balance is maintained by his outstretched right hand.

This sketch gives about as much information as is needed to reconstruct the pose to make a finished drawing.

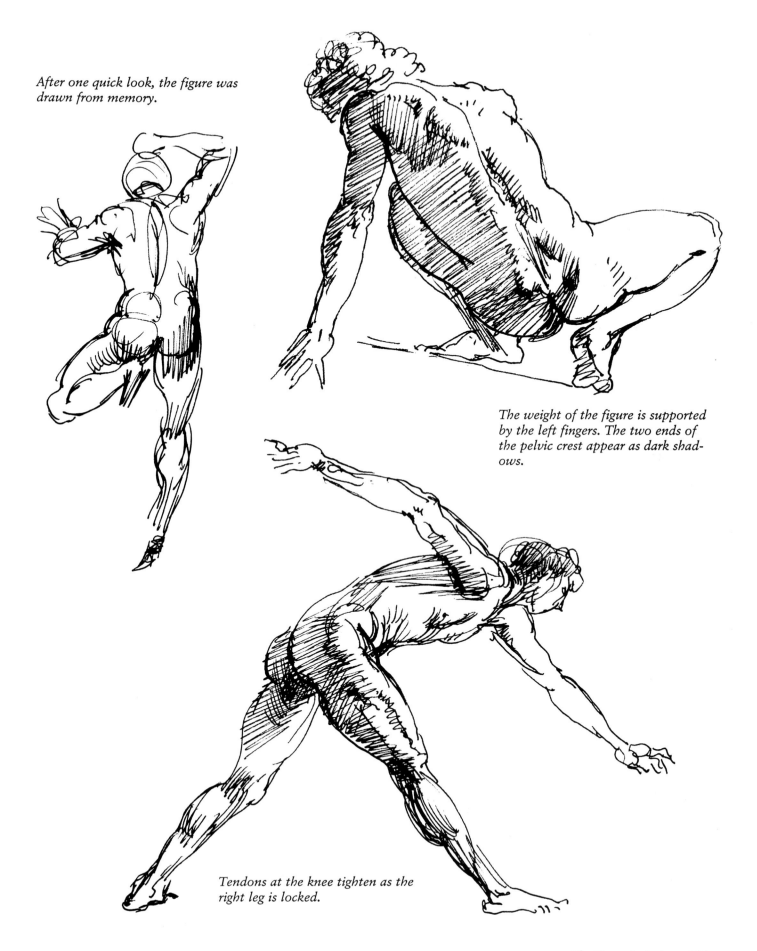

After one quick look, the figure was drawn from memory.

The weight of the figure is supported by the left fingers. The two ends of the pelvic crest appear as dark shadows.

Tendons at the knee tighten as the right leg is locked.

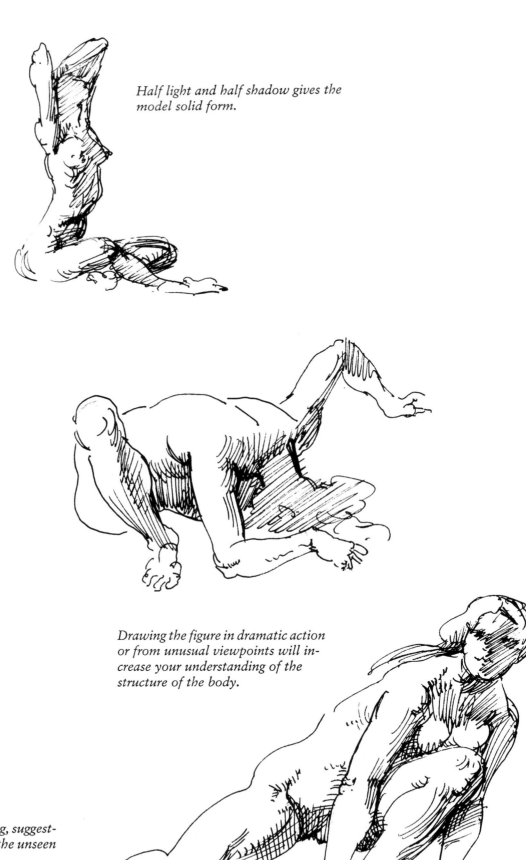

Half light and half shadow gives the model solid form.

Drawing the figure in dramatic action or from unusual viewpoints will increase your understanding of the structure of the body.

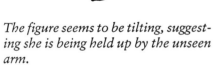

The figure seems to be tilting, suggesting she is being held up by the unseen arm.

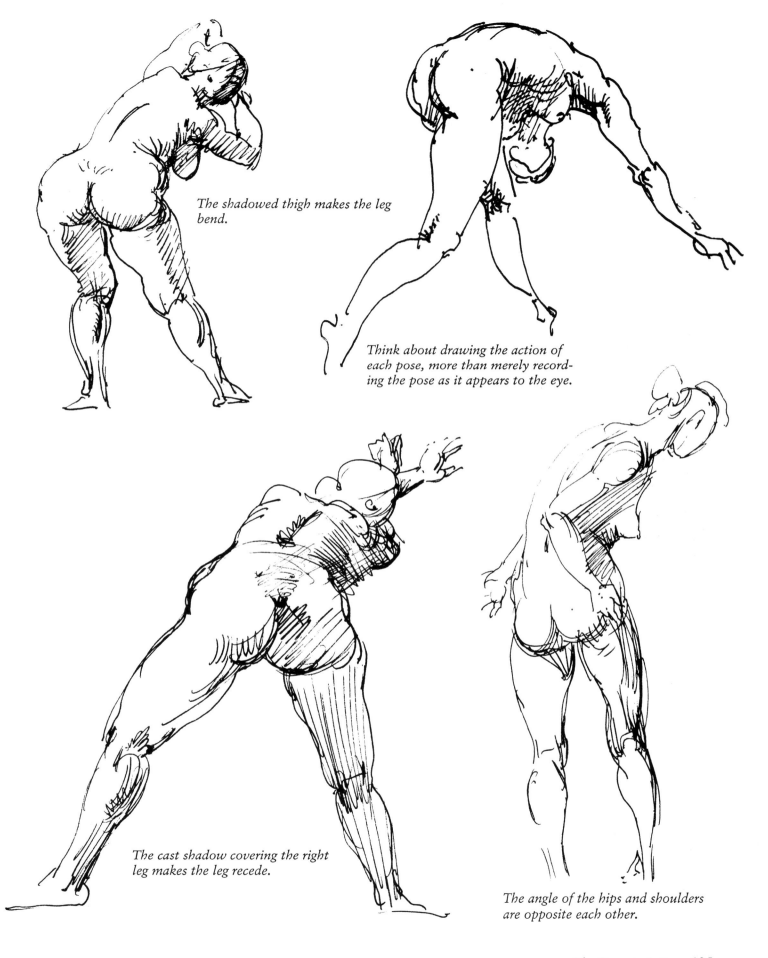

The shadowed thigh makes the leg bend.

Think about drawing the action of each pose, more than merely recording the pose as it appears to the eye.

The cast shadow covering the right leg makes the leg recede.

The angle of the hips and shoulders are opposite each other.

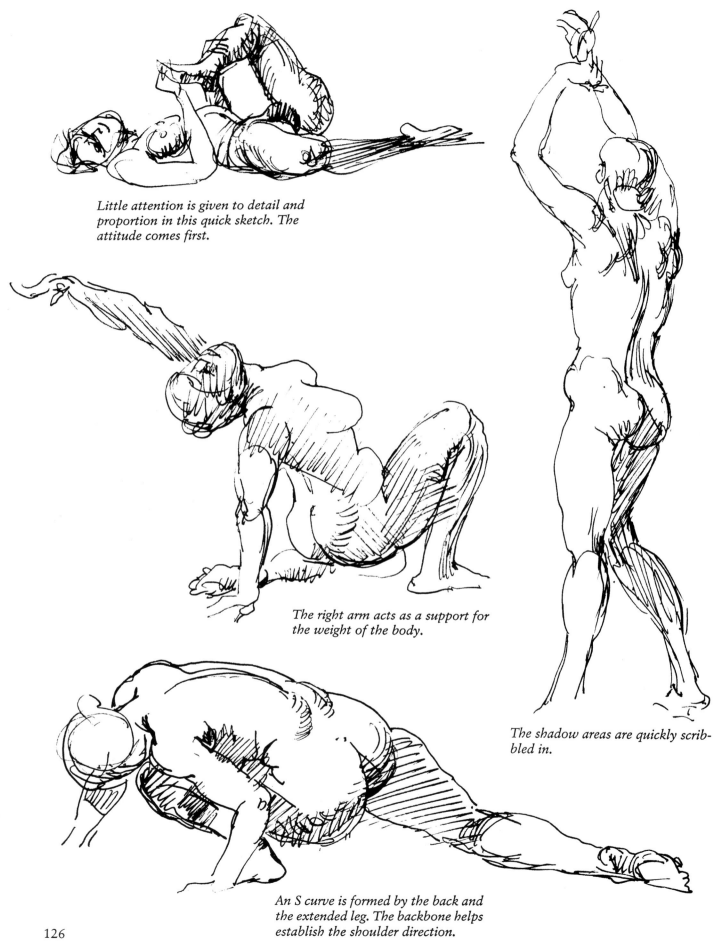

Little attention is given to detail and proportion in this quick sketch. The attitude comes first.

The right arm acts as a support for the weight of the body.

The shadow areas are quickly scribbled in.

An S curve is formed by the back and the extended leg. The backbone helps establish the shoulder direction.

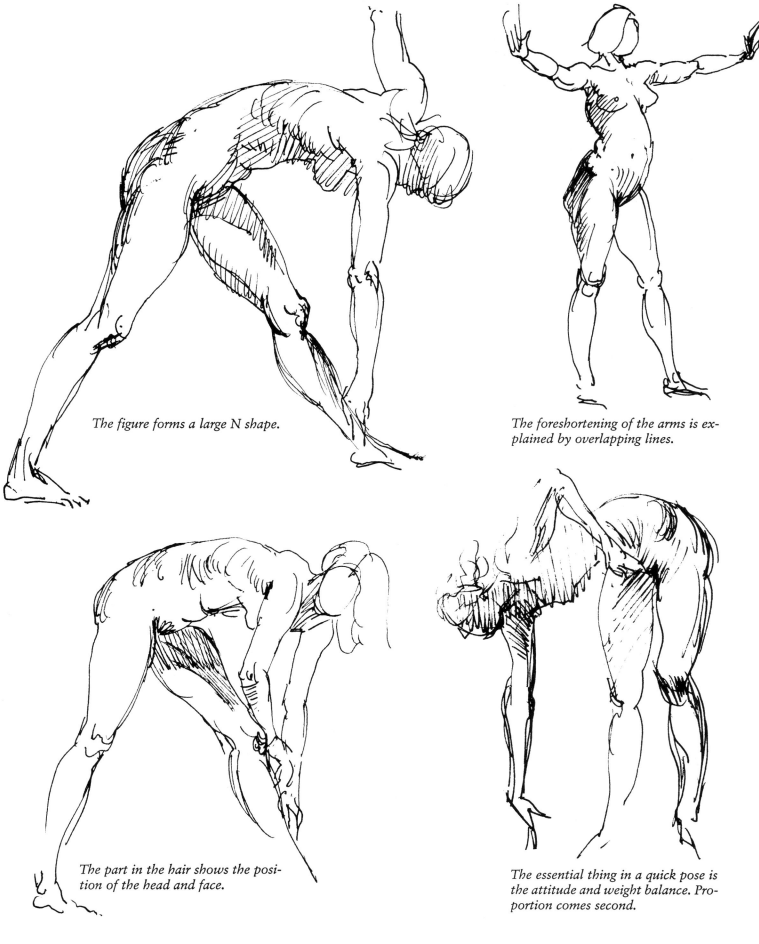

The figure forms a large N shape.

The foreshortening of the arms is explained by overlapping lines.

The part in the hair shows the position of the head and face.

The essential thing in a quick pose is the attitude and weight balance. Proportion comes second.

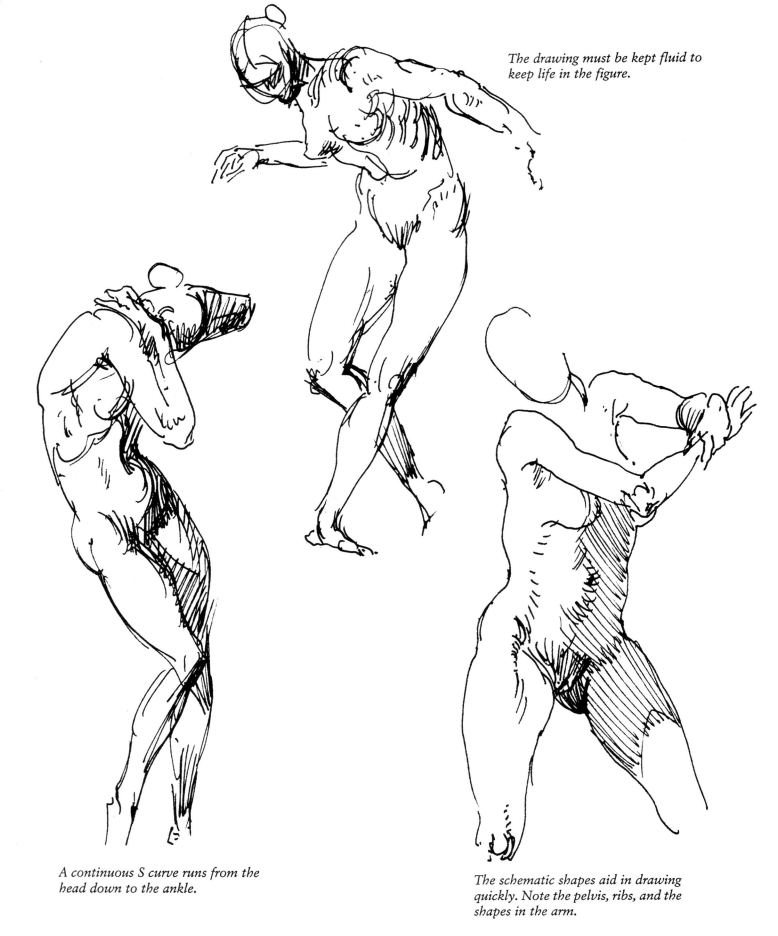

The drawing must be kept fluid to keep life in the figure.

A continuous S curve runs from the head down to the ankle.

The schematic shapes aid in drawing quickly. Note the pelvis, ribs, and the shapes in the arm.

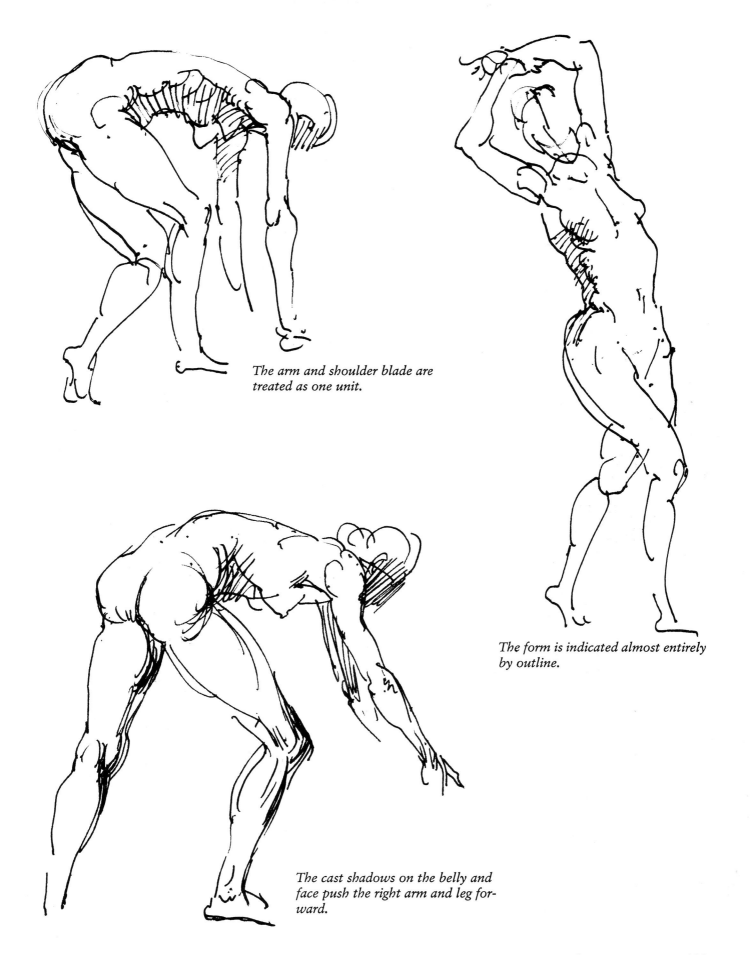

The arm and shoulder blade are treated as one unit.

The form is indicated almost entirely by outline.

The cast shadows on the belly and face push the right arm and leg forward.

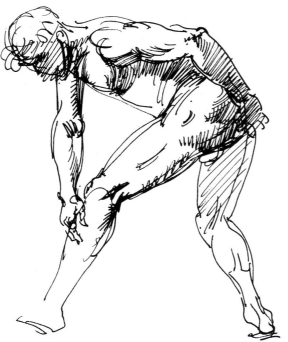

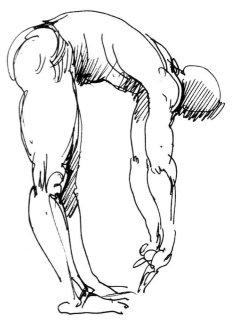

This two-minute sketch allowed
enough time to render the forms more
completely.

The knees are locked, giving the full
leg a slight S shape.

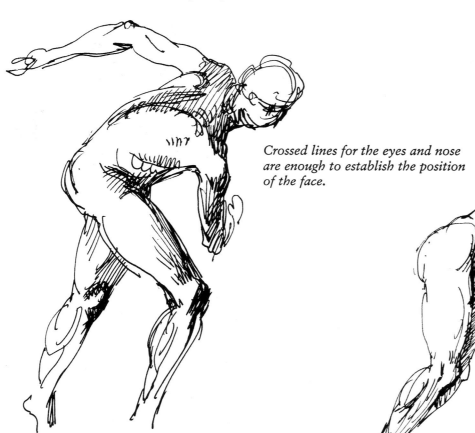

Crossed lines for the eyes and nose
are enough to establish the position
of the face.

The arms support the body; the toes
only act as a balance.

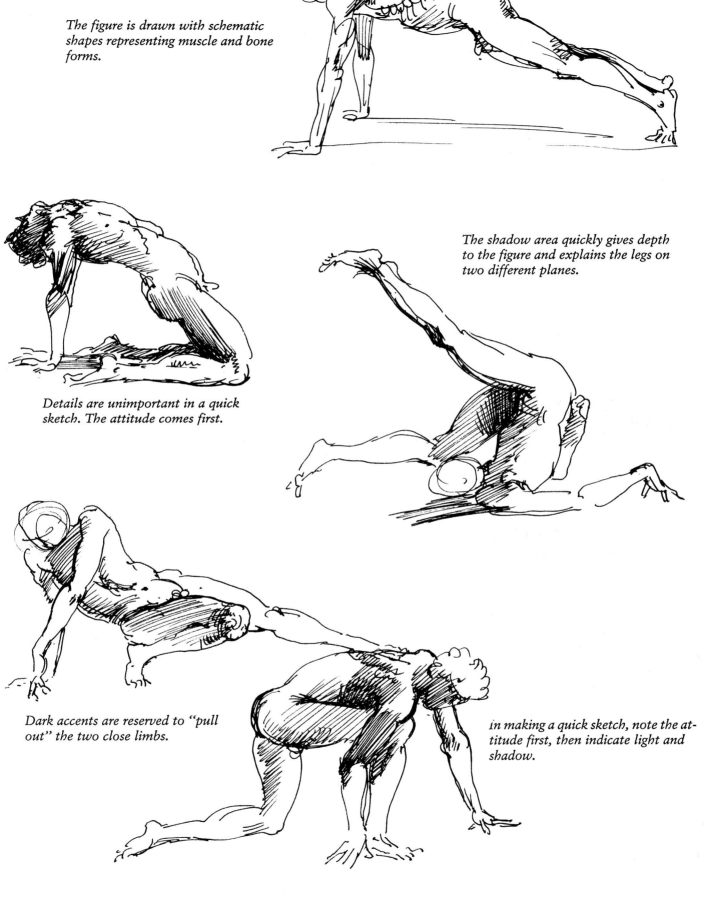

The figure is drawn with schematic shapes representing muscle and bone forms.

Details are unimportant in a quick sketch. The attitude comes first.

The shadow area quickly gives depth to the figure and explains the legs on two different planes.

Dark accents are reserved to "pull out" the two close limbs.

in making a quick sketch, note the attitude first, then indicate light and shadow.

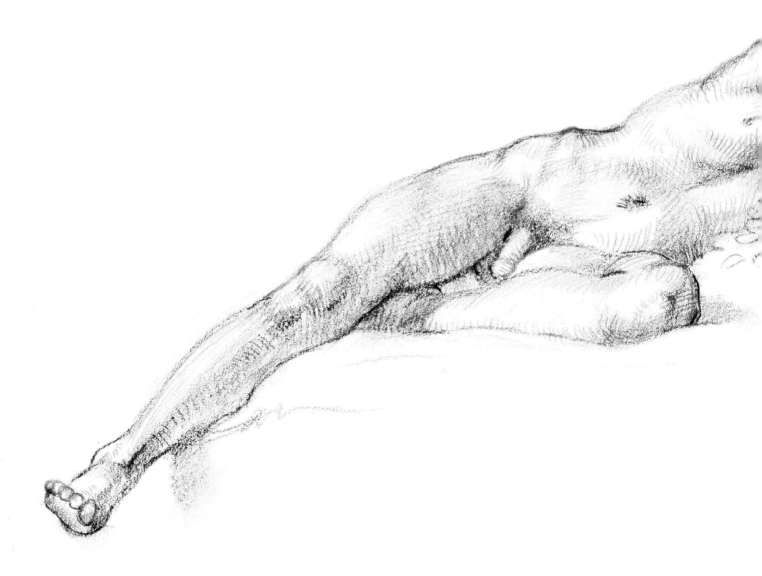

CONCLUSION

I hope this book will offer an insight into the procedures of drawing from life — how to look at the model, what to stress to make a compelling drawing, how to compose the figure. It is only through drawing from life, ideally backed up by studying anatomy and copying Old Masters, that a student will gain the solid foundation needed to render the figure with authority.

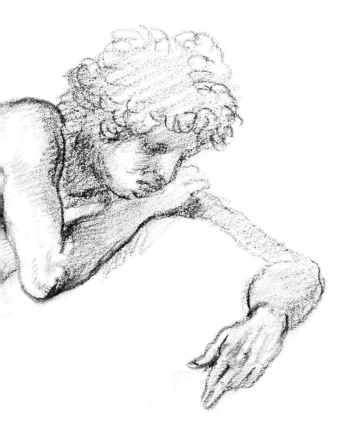

INDEX

Head:
 in figure in action, 118, 127
 in foreshortened figure, 100, 102, 107
 proportion of, 11
Highlight, 12, 14, 50, 93
Hipbone, 71
Hips:
 in reclining figure, 94
 in seated figure, 46, 52, 55, 56

Iliotibial band:
 in crouching figure, 87
 in kneeling figure, 72

Keyline in figure in action, 119, 121, 122
Knee(s):
 in crouching figure, 74, 84
 in figure in action, 123
 in foreshortened figure, 98, 102, 103, 106, 107
 and forms of the figure, 22, 23
 in kneeling figure, 61, 63
 in reclining figure, 96
 in seated figure, 44
Kneecap and ligament, lollipop shape of, 63
Kneeling figure, 60-73
 measurement of, 60, 71

L

Latissimus dorsi muscle:
 in crouching figure, 79
 in kneeling figure, 72
Leg(s):
 in crouching figure, 75, 81, 82, 86, 87
 in figure in action, 118, 121, 123, 125, 131
 in foreshortened figure, 100, 105, 107, 112
 and forms of the figure, 22, 23
 in kneeling figure, 63, 70, 71, 72
 in reclining figure, 88, 89, 91, 92, 93, 96
 in seated figure, 45, 46, 49, 55, 59
 in standing figure, 28-29, 30, 31, 33, 34, 35, 39, 42, 43
 upside-down V shape in muscles of, 23, 33

Light, using single source of, 1, 12, 13
Light and shade, 12-15, 50, 55, 57, 64, 65
Light and shadow, 57, 65, 83, 89, 107, 117, 118, 124, 131

Mannerist artists, 3
Michelangelo, 116
Middle tone, 12, 13, 14, 50
Midpoint of body, 22, 23

N

Neck, 62

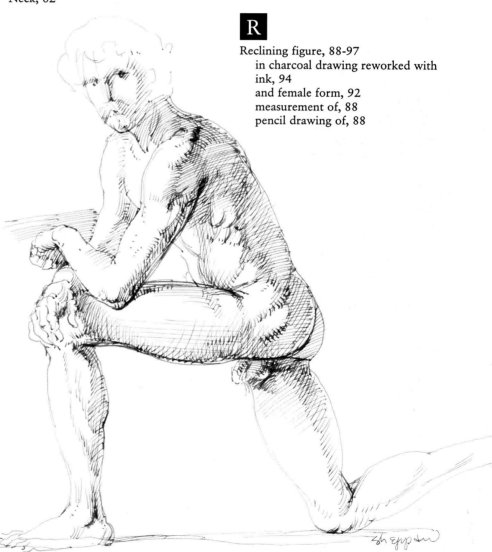

P

Pectoralis, 62, 63
Pelvis:
 in crouching figure, 84
 in figure in action, 117, 123
 and forms of the figure, 17, 19, 20, 22, 23
 in kneeling figure, 67, 68, 73
 in reclining figure, 90
 in seated figure, 51, 52, 56
 in standing figure, 32, 34, 38, 39
Pontormo, 115
Proportion(s), 3-11
 head as unit of measure in, 3
 in reclining figure, 88

R

Reclining figure, 88-97
 in charcoal drawing reworked with ink, 94
 and female form, 92
 measurement of, 88
 pencil drawing of, 88